Advance Praise

"At this specific dark moment of our current history where humanity battles a pandemic, racism, inequity, and the other evils resulting from oppression and never-ending colonialism, and where the self and care are further politicized, Sundus Abdul Hadi offers us a thoughtful and insightful critique of imagination, images, and their representational abilities. Through her personal journey and experiences as an Iraqi woman artist in diaspora, while drawing from diverse sources, she critically unpacks a variety of poignant topics that are global in their nature and impact. She tells a beautiful and poetic story of an 'other's' performative act of negotiation and decolonization of the 'self' in a journey to find empowerment and serenity."

—Nada Shabout, author of *Modern Arab Art: Formation of Arab Aesthetics*

"While reading *Take Care of Your Self*, I was struck by how much I needed this book. I mourned my past selves that didn't have access to this kind of knowledge and specificity, but felt, for the first time, boldly seen and spoken to. This book is a handbook for the many of us that are in the in-betweens of identity, it's for those who struggle to take care, but desperately want to. It's for the many of us that are trying to pave a tender path to healing, who seek guidance. This book is a light to the path forward."

—Fariha Róisín, author of *How to Cure a Ghost*

"There has never been a book that so aptly captures so many examples of creativity from the region and beyond, reflecting so eloquently both our struggles and triumphs. I look forward to using Sundus Abdul Hadi's book in my curriculum. I finally have an answer for those who continuously ask about the role of art in society."

—Sultan Sooud Al Qassemi, founder, Barjeel Art Foundation and lecturer of Modern Middle Eastern Art

"Sundus Abdul Hadi offers an insightful exploration of decolonial artistic, curatorial, and cultural practices, while centering 'self-care' as a radical tool for social transformation. The book presents a refreshingly lucid account of Iraqi/Arab identity confronting compounded challenges, given multiple diasporizations in the wake of devastating wars and intergenerational trauma. But as a collaborative cross-border project, the text moves from grief to alliance with various communities, especially with Black and Indigenous movements in North America. Deploying a lens at once transnational and multidisciplinary, Abdul Hadi interweaves her personal story with diverseism in what becomes an exhilarating manifes.....

—Ella Habiba Shohat, author of *T*

"This book is just the companion we need during this isolating time, when we are collectively fighting for Justice. Abdul Hadı guides us to care and shares the healing practices of other artist guides. A beautiful light."

—Randa Jarrar, author of *Love is an Ex-Country*

"There could not be a more relevant and needed gift at this moment than *Take Care of Your Self.* Sundus Abdul Hadi not only restores dignity and urgency to the word 'care,' but also slows the reader down to take in its true meaning. The recalibration of words that follow, like solidarity, decolonization, and safety, foregrounds their meanings through the fearless testimony of lived experience of the author and her cohort of thinkers, artists, and activists. What Sundus Abdul Hadi has created here is not simply a book; it is a living room that nourishes us in a moment of uprising and unsettling and offers us terms and tools to help us heal, repair, and envision a more care-full world to come. *Shukran*, Sundus. *Achat eedech* (bless your hands)."

—Michael Rakowitz, author of *A House with a Date Palm Will Never Starve*

"In June Jordan's poetic evocation of 'Moving Towards Home,' the intimate and spectacular violences experienced by Black women and Palestinians under the boot of colonialism are inextricably bound by their suffering and equally so the shared horizon of their aspiration for refuge: 'Living Room' for return, for reproduction absent the excruciating violence of the wage, the bomb, the cage. Sundus Abdul Hadi's stunning hybrid collection *Take Care of Your Self* weaves memoir, tools of healing justice, and an archive of artists answering the call for more Living Room. At the center of a slew of antiracist mobilizations, masses rising against empire across the world, the entangled dignity of generations of the wretched of the earth, their diasporas, and their children: sits the artist, and as Abdul Hadi demonstrates, at the center of the artist is an interior and internal negotiation for spiritual sustenance and resilience—to forge the will to carry us to the next world. This book is for those curious about solidarity as an embodied, creative, and living practice. We need your imagination unbounded, and we need you alive and well."

—Zaina Alsous, author of *A Theory of Birds*

"*Take Care of Your Self* is a beautifully written tapestry that has woven together the histories, trauma, joys, art, and experiences of people who have not been allowed the space to heal, not given the permission to care, and have been divorced from their/our ancestral modes of communal love. Abdul Hadi's compassionate writing and art gives us the language and tools rooted in our own tradition to demand better for ourselves and our communities. This book is a must-read to begin the journey of decolonial healing and essential to imagining a world rooted in care, not capitalism!"

—Hoda Katebi, author of *Tehran Streetstyle* and founder of
 #becauseweveread

TAKE CARE of YOUR SELF

The Art and Cultures of Care and Liberation

Sundus Abdul Hadi

Brooklyn, NY | Philadelphia, PA
commonnotions.org

Take Care of Your Self: The Art and Cultures of Care and Liberation
by Sundus Abdul Hadi

Print ISBN: 9781942173182
Ebook ISBN: 9781942173403
LCCN: 2020941310
10 9 8 7 6 5 4 3 2

Common Notions
c/o Interference Archive
314 7th St.
Brooklyn, NY 11215

Common Notions
c/o Making Worlds Bookstore
210 S. 45th St.
Philadelphia, PA 19104

www.commonnotions.org
info@commonnotions.org

We Are The Medium
www.wearethemedium.com
@wearethemdm

Copyediting by Erika Biddle
Cover design by Josh MacPhee / Antumbra Design
Layout design and typesetting by Morgan Buck / Antumbra Design
Antumbra Design www.antumbradesign.org

Printed in Canada

Table of Contents

From the Macrocosm to the Microcosm.

For my community.
For my family.
For Bibi Sajeda.

FOREWORD

By Emily Jacir

July 22, 2020

In the last 48 hours, Israeli forces have invaded Bethlehem
district in a pre-dawn raid to loot a baptismal font dating
back to the Byzantine era; demolished a COVID-19 cen-
ter in Hebron; and as of this morning arrested the directors
of Yabous Cultural Center and the Edward Said National
Conservatory of Music, and raided their cultural institutions.

My head is reeling. Breathe. I feel weighed down by
the daily accumulation of these traumas. . . the same ones
my parents lived through and their parents lived through. I
open Sundus' book and read these words:

Where do these memories live? Where can we file away trauma?
Most importantly, when do we start to heal? (23)

April 30, 2020

I meet Sundus Abdul Hadi online in Michael Rakowitz's
"In defense of blankness over busyness: an anti-master
class on cooking dinner at the end of the day" or "Toasts,"
which we are hosting at Dar Jacir.* Each participant is
asked to make a toast. It is two months into the lockdown
in Italy and I have been thinking a lot about solidarity. I
have been reflecting on my friendship with Michael, which
has spanned two decades, sharing life-altering events like
the second intifada, 9/11, and more. I decide to toast to
that and to the hope that the younger generation of artists
in Palestine will be able to have the kind of solidarity with
other artists that I have had in my friendship with Michael.
Solidarity and hope for the next generation. . . and a toast

to new friendships from this online encounter and new alliances. I recount to the group that at the beginning of the coronavirus lockdown I found out that a Palestinian institution had neglected to include my curatorial essay in a book they published on an exhibition I had curated and organized. This was an exhibition that I worked on for over two years and that I had considered one of the most important in my life working with the ten young Palestinian artists. How could they forget? (My emails asking for answers from my colleagues remain unanswered to this day.)

During the gathering we share a lot of silence together. Michael mentions that the coronavirus has possibly created conditions for us to listen fearlessly. Listening a lot closer—in a more committed way than we were before. Holding space for each other. There we all were in that mad moment of isolation and lockdown all silently staring at each other on a screen and processing silence together.

Sundus speaks reflecting on the omission of my curatorial essay and articulates this point: "One of the ways we can go about bringing systemic change is by bringing back the idea that our industries have to be more careful and more caring. We have to have that conversation. There is carelessness and a lack of care in our industries in general."

I had not realized that that was precisely what was missing and exactly the problem with how the institution had treated me and my exhibition.

April 30, 2018

I am hosting Michael in Bethlehem and we are running a workshop called *On the question of making art in cities under siege: exploring the intersection of hospitality and hostility*—the inaugural workshop at Dar Jacir. The people renovating our house have locked us out and refuse to let us access the building (a case in which not only care was missing but also such a violent act). Never mind, I decide to forge

ahead, we will hold the workshop all around the house, in the garden, and up and down the street, each day with a different neighbor.

(I)magination is a factory where hope is manufactured. If the counternarrative to violence is care, then that's where you'll find me. (31)

While reading Sundus' book and reflecting on experiences I have witnessed over the last twenty years, "care" and the discourse around it is the most urgent issue facing our cultural landscape today. In the West Bank, for example, the deep lack of care embedded within the structure of the neoliberal institutions that have exploded out of control from 2003 onwards is alarming. As a witness to the slow decline of how we care for each other in these institutional spaces, there is much to recount.

It has to do with the deep impact of colonialism, imperialism, and corrupt systems disguised as democracy. It has to do with systemic change, from the inside out. (27)

April 24, 2016

After years in a traumatic situation and wondering how I got myself into it, I am in Dublin furthering my ongoing research in Ireland to looking at how trauma across generations plays out within families and societies—the things that happen behind closed doors that nobody talks about. The Irish had endured centuries of colonial rule and shared with us a heritage of brutal and violent occupation and resistance to that. How did living through generations of abuse, conflict, and trauma affect their families? How did people treat each other within families, and how did society become ill? Structures? I wanted to find out how this intergenerational trauma played out in everyday life now and how it impacted the way people treat each other.

It is perhaps this position that enables me to connect to other communities that suffer the same symptoms, caused by the same disease: foreign entities claiming power over entire nations of people, rewriting history, and installing their oppressive structures for us to stumble within. (27)

January 30, 2003

Today *Shatat* opens at the University of Colorado at Boulder, a contemporary Arab art exhibition I am participating in. It was meant to take place at the Boulder Museum of Contemporary Art but the museum asked the curator to remove the "Palestinian" artist (still common practice to this day in the US while being perfectly happy to showcase Arab artists from Egypt, Lebanon, Tunisia, and Algeria). When faced with this, the curator Salah Hasan decided to remove the show from the museum completely and instead chose to hold it at the local university in Boulder. Little did I know at the time how rare such a beautiful act would be coming from my own community—a curator facing censorship and responding with action out of solidarity and community care.

June 4, 2009

My work is censored in the first ever Palestinian Pavilion in Venice—I am asked by the curator to keep quiet and not cause a scandal. Not one single participating artist in the pavilion has my back—all want me to be quiet. I am empathetic and sensitive to the difficult political realities of our first ever Palestinian Pavilion and I do not want the circumstances of the "cancellation" to eclipse our exhibition. The pavilion organizers decide that since there was never an "official" printed letter rejecting my project that it is best to keep quiet. When I am first informed about the cancellation, I am told that if I go public, my actions would impact the other artists in a harmful way and that I would also be harming the current and future Palestinian participation in Venice.

"The press will have a field day with this and will not talk about the other artists," I hear over and over again. According to the curator, when she asked for help in the matter from the European Parliament member and long-time supporter of the Palestinians, Luisa Morgantini, her response is, "It is best not to make a big thing out of this at this time. It is not good for Palestine or the exhibitions at Venice, and it will not help us in any way." At the opening ceremony of *Palestine c/o Venice,* where several notables make speeches, Laila Shahid announces, "We are very sorry Emily Jacir's project was not accepted." That was it. Everything that happened was swept under the rug and reduced to that. I have a great conversation with Jean Fisher who speculates that "the blockade on publicity about your project for the sake of preserving the event could even have deterred solidarity with you among the other participating artists."

The military strategy of divide and conquer wants to see us at odds with one another, rather than in solidarity with one another. (27)

"Care" was not part of my lexicon and indeed not part of the world I came out of, but it has been very much there in my practice since the early nineties, something I knew instinctively. "Memorial to 418 Palestinian Villages which were Destroyed, Depopulated and Occupied by Israel in 1948" created between 2000 and 2001 was a three-month community-based project in which I stenciled the names of all the villages onto a family-sized refugee tent, and then invited people to come sew the names of the villages. Over 140 people came through my studio to embroider the names while telling stories, socializing, or recounting how each village was destroyed. The people who made the Memorial were bankers, lawyers, filmmakers, dentists, consultants, playrights, artists, activists, teachers, and more. It was the only safe space we had in the city at the time—the second intifada was raging and we were all under attack both at home in Palestine and in the New York press. People were coming to gather at the studio every day, and by night, Arab musicians

were coming by after their own gigs to play for us while we sewed. These gatherings took place during a pivotal moment in the history of Palestinians in the US, when we were a political and secular movement fighting for justice, and it was when the right-of-return marches had hit their peak with massive marches taking place on the streets. Sadly, after 9/11 this community was obliterated and "Arab" America died. I mourn the loss of the Arab community now subsumed under a religious category— "Muslim"—falling neatly into the Bush definition of the world, thus rendering us invisible. After that fateful day in September, my community and I could not mourn because we were under attack ourselves. I quickly spearheaded and organized an escort system to protect mothers and children on their way to schools from being attacked. There was no time to breathe. The community needed so much protection and care. Everything about who we were was being eradicated by the mass media, often in collaboration with many members from our own community that were only too happy to fall under these divisive Bush categories. I also remember being stunned that for New Yorkers the world stopped and they actually had space to mourn—to this day I have never had the privilege of experiencing that kind of space and time after a trauma because we are already always dealing with the next one and we have to keep going. We have to keep going. It was one year after 9/11, in my apartment in Ramallah that I was finally able to mourn—alone—and reflect on what had happened, acknowledging that part of my mourning was also about being left out of the collective mourning in New York on account of being an Arab.

We hold this space by grieving and healing together. We celebrate struggle and otherness, because oftentimes, those two experiences are synonymous. (151)

Hosting, empathy, and caring for my community have been key pillars in my practice, not only in the works themselves but also through creating spaces to gather and making space within institutions. By bringing my community into the institutions,

they are there not as spectacle but as active participants. In 2005, I held a solo exhibition in Wichita, Kansas, and the majority of those who showed up at the opening were Palestinians. They were mostly transplants from Borj al Barajneh refugee camp in Lebanon who had lived in Wichita for years but had never been inside the Museum before. They entered for the first time and it was *their* space. Their story and narrative were part of the institution. I fought hard for that space—the Museum had initially tried to censor my work, but we managed to prevent that from happening. Fight we did.

Take Care of Your Self lays out an essential framework, that had I had access to when I was younger, there would have been a very different outcome to my life today. The theme of care in this book gives me hope for the future, particularly for other artists navigating this field. In writing this book, Abdul Hadi is also opening up space to continue talking off the pages and to share historical precedents which have not been recorded or have been forgotten. It is an opportunity to revisit and to rearticulate what we have done. To record a history. To share stories cross-generationally. To rethink stories and experience through this lens and to articulate them together. Like Sundus' grandmother Sajeda, my father also taught me that education is my weapon. Now it is up to us to have these intergenerational dialogues and to educate and foster the space to rebuild and rethink—and so much of that is language and articulating that which was, for so long, unspoken.

Finally, my deepest gratitude goes to Sundus, who opened up a space for my words to land and a new lens to look through.

Emily Jacir
Rome, Italy
August 1, 2020

* Dar Yusuf Nasri Jacir for Art and Research is an independent artist-run space in Bethlehem. In March 2020, foregrounding solidarity and care, the Dar Jacir team created an online program focused on bringing together their family of artists, writers, musicians, filmmakers, and dancers to lead programs online. The focus was on deepening and strengthening their already existing ties with their community and one another and to provide the Dar Jacir community with a way to stay together while being physically separated.

PREFACE

As an artist-curator of Iraqi origin, my journey of exploring the concepts of care and struggle all started with writing a short story called "Shams." Shams is a little girl made of glass. One fateful day, Shams breaks into a million pieces. In the story, Shams transforms from a fragile little girl into a survivor, with the help of her own imagination and the guidance of Shifaa, the healer. In the story, we follow Shams as she puts herself back together again and searches for justice and liberation. I wrote and illustrated the short story following a personal, traumatic experience in my homeland, Iraq, and my journey of healing from it. I know that my experience is not unique: trauma, loss, and displacement have become universal experiences affecting colonized communities from the Middle East to Turtle Island and are generations deep. As a starting point for my research-creation into decolonizing care, writing "Shams" cast a wide net, bringing together the multitude of concepts I explore in this book: the transformative power of art, imagination, and curation born out of the diverse struggles of *deeply rooted* communities with the potential to heal and empower.[1]

The book you hold in your hand is rooted in lived experiences of care and struggle. Its first iteration was an exhibition and series of events held in Montreal in the summer of 2017, titled *Take Care of Your Self*, which showcased much of the art within these pages on the white walls of a pop-up gallery on Boulevard Saint-Laurent. The conversations that were held in that caring, safe space now transform into the words on these pages, and the ephemerality of a week-long exhibit now gets life-long expression in this book. Through the exhibit and this book, I am bringing together artists who use their respective art practices to intellectually and emotionally engage with the complex issues of

1. "Deeply rooted" is an empowered phrase I use to replace white-centering descriptions of identity such as "marginalized," "racialized," and "colonized." I explain the intention behind this in greater detail in the section "New Word Order" in Chapter 1.

care, struggle, trauma, and empowerment. The most impactful result of this work is its role in connecting artists to one another, creating a community of artists engaged with similar concepts of care and struggle. In Suhad Khatib's own words, written out in the exhibition's guest book, "*Shukran* (Arabic for 'thank you') Sundus for connecting me to the artistic network that heals." I extend the *shukran* back to Suhad and the artists who joined me on the journey through the exhibit and into this book.

Self-care is a necessary practice for many of us who struggle with trauma and mental health challenges resulting from structural oppression, colonialism, racism, loss, and displacement. This book represents a safer, mediated space of care narrated by transcultural artists, offering a remedy to soothe the collective grief manifesting in so many of our deeply rooted communities. The consequent politicization of self-care is a practice that many artists and writers are consciously cultivating, offering the reader a sense of empowerment in light of traumatic personal and/or global events.

I have chosen to locate myself within this discourse, first by being both a practicing artist and a curator. Claiming the space of artist-curator shifts the power dynamics of an industry that is often built on hierarchy and exclusion. Digging into my own experiences as an Iraqi artist working on the margins, I hope I can illuminate the path that brought me here, writing this very book about care, struggle, community, and storytelling through art, and why I believe in it so deeply.

So, in the spirit of "Shams," I hope that I may offer a space for rebuilding ourselves and our communities through a rigorous reflection on our struggles and our stories, by offering methods in decolonizing care through art and examples of its transformative power.

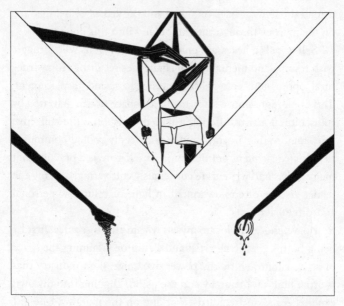

"A Healing"
Illustration from the book *Shams*
by Sundus Abdul Hadi
Ink on Paper, 2015

Suheir Hammad
@yosuheirhammad

'who cares?'
actually always a good question
it's the tone that sucks

#bossa

8:50 AM - 9 Apr 2019[1]

Introduction

So verily, with the hardship, there is relief, Verily, with the hardship, there is relief.

—The Holy Qur'an (94:5–6)

Take care of yourself. How many times a week do we hear or say these words in passing? If we all took the time to care for ourselves, how much stronger would we be? More importantly, how much stronger would our communities be?

While colonialism, neoliberalism, imperialism, capitalism, corruption, occupation, patriarchy, racism, and various forms of oppression define the center, the people who have been relegated to the margins have been subtly healing themselves and others through their struggles against these violent systems. For those of us who are beacons of light in a dark world, the struggle for self-determination is a consciousness that drives our very existence. No matter how beat down we get, one ultimate goal still defines our struggle: liberation.

A collective consciousness defined by liberation and self-determination has been consistently growing and reaching

1. These tweets were written by poet Suheir Hammad between 2013 and 2019. They are Hammad's contribution to *Take Care of Your Self*. Hammad's perspective on care has deeply informed my own, and her engagement on social media has often highlighted issues of care mirrored in this book.

critical mass, as we are seeing through revolutions and movements from the past decade in Standing Rock, Ferguson, Minneapolis, Tunisia, Egypt, Syria, Gaza, Chile, Iraq, Lebanon, Algeria, Sudan, and elsewhere. Many of these communities have been impacted by intergenerational trauma as a result of the various "-isms" mentioned above. People around the world know they will only reach their goals with radical systemic change and are standing up to these oppressive systems that are plagued by corruption, violence, and socioeconomic injustices. As different as each struggle is from the other (it is impossible to paint each unique movement with the same brush), there is a fascinating phenomenon that links each community to the other.

I believe we are witnessing an evolution in collective consciousness rooted in decolonization. This particular evolution of self is only possible after a period of healing. If we were to liken national psychology under oppression to a person raised under abuse, as Frantz Fanon has written about extensively, then we can also flip the perspective. Rather than focus on the symptoms of abuse, we can focus on the processes of healing and care as the positive counterparts to struggle. I see so much potential here, both for individual selves and for communities who have endured more than what anyone should have to—in terms of loss, displacement, war, violence, and systemic injustice.

The ability for a human being to express and experience joy after so much suffering is one of the most incredible aspects of the human experience, to the intransigence of their oppressors. Just as individuals work on their own well-being through self-care practices, therapy, and various forms of healing, so do communities work on their well-being through care work and various forms of collective healing that are in a myriad of ways bound up in their struggles for liberation. In fact, it becomes absolutely necessary for both individuals and communities to engage in care work and healing, particularly in societies where trauma is endemic.

The role of the artist in these instances becomes an important responsibility, and in every movement, artists have been on

the frontlines. A recently written article by Khalid Albaih, a Sudanese political cartoonist, perfectly captures the moment in which we now find ourselves:

> Sudan's artists have a new fight on our hands. As the last waves of protests fade from the news, we need to shift our focus to healing ourselves. Talking about trauma is a relatively new concept in our culture. We were never taught the language to cope with what happens after the fight—we were just taught to stay out of trouble. But so many of us are suffering from trauma and the emotional toll of failed revolutions; from the fatigue of resisting, over and over again; from seeing people killed around us. For many of us, our trauma hasn't even had time to settle in yet. But when it does, we are going to need relief.[2]

In the spirit of the brave women, men, trans and gender nonconforming folks, elders, and youth in the resistance, I hope to share some of the insights that I have gathered along the way, as an artist and curator, in how self-care and community care practices can support our efforts in persisting in the struggle for a more just world.

2. Khalid Albaih, "We used our art to fight. Now we need it to heal us," *Quartz*, June 19, 2019, https://qz.com/1647050/sudans-artists-need-to-address-the-trauma-of-protest/.

Suheir Hammad
@yosuheirhammad

'deeree bal'ek'
turn yourself curve yourself take care your self
@SundusAH light to the fam habibti

#bossa

8:07 AM - 15 Jun 2017

CHAPTER 1

KNOWLEDGE OF SELF

Revolution begins with the self, in the self.

—Toni Cade Bambara, *The Black Woman: An Anthology*[1]

Roots

I have always been a visual person. My home life was in stark contrast to the visual representation of an Iraqi, Arab, Muslim, immigrant stereotype. Coming from a family of artists, culture and heritage reigned supreme. My parents were a great influence on me creatively. My mother was always creating in our home—painting, sculpting, drawing, and sketching. Because of her, we were surrounded by art our whole lives. My father's collection of books on Iraqi heritage and Islamic art and architecture are some of my most prized possessions. I spent my university years using those books as resources for my artistic practice and art history papers. In fact, I even used some of them as references in this book. Studying art in a Western institution, I was really starved of content that I could relate to, that spoke to my

1. Toni Cade Bambara, ed., *The Black Woman: An Anthology* (New York: Washington Square Press, 2005).

identity as an Arab.[2] Those books started me on a journey of self-exploration through our visual culture that I'm still deeply interested in.

I studied Studio Art and Art History for my undergraduate degree. In September 2002, on my first day of class as a young wide-eyed student, I sat in the Art History class quite nervously. The professor entered the auditorium and introduced the class by reading from a report written by the American Council of Trustees and Alumni, titled "Defending Civilization: How Our Universities Are Failing America and What Can Be Done About It."[3] The professor continued by saying that the report was endorsed by Lynne Cheney, wife of Dick Cheney, the forty-sixth Vice President of the United States (and a war criminal, alongside others in the Bush administration, responsible for the destruction of Iraq). The report states that universities teaching Islamic and Arabic culture and history are in fact supporting the terrorist acts of 9/11 and are sympathetic to the terrorists. I was sure that she would throw the document on the ground and say, "Absolutely not! That's all propaganda!" But to my surprise, she said, "That's why in this class I'll only be teaching you about the achievements of Western art history." I was in shock. As soon as the professor called for a break, I walked out of the class and dropped out of the course. A week later I was reading Edward Said's *Orientalism*, finding words that contextualized the impact of colonialism on representations of the East. Said describes Orientalism as "the corporate institution for dealing with the Orient—dealing with it by making statements about it, authorizing views of it, describing it, teaching it, settling it, ruling over it: in short, Orientalism as a Western style for dominating, restructuring, and having authority over the Orient."[4] Before long, I understood these phenomena intuitively, especially with

2. The term *Arab* is oftentimes overly generalized and homogenizing to the multiplicity of ethnicities within the Arabic-speaking world. I extend it to recognize and include other ethnic groups that may or may not identify as Arab, such as Afro-Arabs, Kurdish, Assyrian, Armenian, Circassian, Turkmen, Yazidi, Shabak, Amazigh, Bidoon, Arab Jews, and others.

3. For the full text of this report, see http://www.mafhoum.com/press2/71P5.pdf.

4. Edward Said, *Orientalism* (New York: Vintage Books, 2003), 3.

regard to the coverage of the 2003 invasion of Iraq ("Operation Iraqi Freedom") in the US media. Reading the work of Said, a Palestinian cultural theorist, was extremely empowering in an academic landscape that has very little representation of non-white scholars.

I struggled a lot in art school because the faculty and students couldn't engage with my work and my identity, and were ill-prepared to deal with the sociopolitical issues I explored through my work. The Iraq War was raging and Islamophobia was on the rise, yet the professors were urging me to move away from those topics, and/or gave me stereotypical readings of my work. After graduating with a BFA in Studio Art and Art History, I decided to pursue graduate work in Communication Studies. It was in that department that I felt encouraged to continue my work on projects that related to identity, representation, and media, while still maintaining my art practice through my academic work. Fast-forward to today, with a Master's in Media Studies, I have armed myself with the skills and sensibilities to articulate how the negative narratives that circulate in our media sphere can be transformed. I explored the topic of representation in depth in "Warchestra," a multimedia project of visual and sonic components that transformed images of weapon-wielding militants from the Arab world into musicians and cultural producers. This project originated from a series of paintings combatting the stereotypical image of Arabs in the Western media as gun-toting and violent people, functioning as a form of censorship and also as an act of resisting stereotypes. The project evolved into an act of empowerment through culture, highlighting the cultural heritage of the Arab peoples amidst an ongoing backdrop of war and destruction.

Stories give me life. They help to balance out the damaging misrepresentations of my culture in Western media and help me define my own story and experience as an Iraqi artist in the diaspora. For years, I meditated on the heavy cloud of war and displacement, finding in it the stories I shared through my art to bring justice to the unheard and unseen. Then one day, in my ancestral city Baghdad, that dark cloud enveloped me, and my

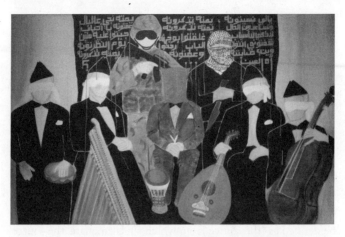

"The Forgotten," from the *Warchestra* series
by Sundus Abdul Hadi / Acrylic on canvas, 30" x 48" / 2009

world turned upside down. I couldn't take in any more stories of war. I stopped reading the news. After that, I couldn't watch or read anything that had any reference to violence. None of the stories felt responsible to the trauma we carried in our bones. I (we) needed to heal.

Images speak to me in great volumes, and I believe in their power to heal and inspire. I also believe that images can (re)traumatize, misrepresent, stereotype, and create negativity both within ourselves and in our communities. It was time to imagine new narratives and representations of our experiences. Growing up Iraqi on Turtle Island while the war and illegal occupation in Iraq was raging, all I saw were images of my people that did not do justice to the rich cultural heritage of my motherland nor the powerful resilience of its people. In reclaiming and reimagining our stories and images, decolonizing work begins.

Al-nafs

Know yourself that you are the world's soul.

—Mahmud Shabestari[5]

In Arabic, the words self, soul, psyche, and breath all share the same word: *nafs*. Manifested through the breath and connected to the ego, the self can take on many states and both positive and negative attributes. Of the positive attributes within self, self-awareness and acceptance arises, as well as peace, inspiration, care for others, and in its pure form, spirit [*rüh*]. *Rüh* can be defined as "the source from which souls emanate, the source at once of their existence and of their light,"[6] as defined in *The Sense of Unity: The Sufi Tradition in Persian Architecture*, a book that has been greatly influential throughout my artistic practice.

The journey of healing my own wounds has inevitably taken me down a path of spirituality and self-discovery. The process of writing this book started with the self, with the intention to heal my mind/body/spirit from the trauma I carried with me, literally taking my breath away. For years after experiencing postwar Iraq, I couldn't breathe full and satisfying breaths, always coming up short, suffocating, and suffering silently. I became fixated on this shortness of breath, looking everywhere for answers and relief. While doctors were eager to prescribe me anti-anxiety meds, I reached into the timeless guidance of the Qur'an, started a yoga practice, and discovered the incredible tool of conscious breathing or *pranayama*. According to Vasant Lad, "Pranayama equals *prana* plus *ayam*. *Ayam* means 'to control,' *prana* is 'breath.' By controlling the breath, we can control mental activity."[7] And, naturally I reached toward art. Always art. My artistic practice is a sacred space that invites

5. Mahmud Shabestari, Gulshan-i-râz, quoted in Nader Ardalan and Laleh Bakhtiar, *The Sense of Unity: The Sufi Tradition in Persian Architecture* (Chicago: University of Chicago Press, 1973), 8.

6. Ardalan and Bakhtiar, The Sense of Unity, 141.

7. Vasant Lad, *The Complete Book of Ayurvedic Home Remedies: Based on the Timeless Wisdom of India's 5,000-Year-Old Medical System* (New York: Three Rivers Press, 1999), 71.

deep self-reflection, self-awareness, and critical thinking. I see art-making as part of fulfilling my life purpose, where I get to ask the big questions I am grappling with and visualize the answers, or ask further questions along the way.

After experiencing a second and more pointed trauma, I reached a new point of physical anguish. That process of healing was disciplined and all encompassing. It took years of self-care, a dedicated practice of yoga and prayer, dozens of spiritual texts, and angels in the form of human connection. The point of transformation for me came after writing "Shams," the story of a little girl made of glass. The story came as a result of healing, and not as a part of the healing process. I had to do the Work[8] before I could access the ancestral wisdom that I carried within me and in return, share it with others through my artwork. Arriving here has involved an unbelievable sense of togetherness. If suffering is a very solitary and isolating experience, healing, transformation, and ascension are based on connection, unity, and sharing. I believe in the potential of traumatized individuals and communities to carve out pathways to a deeper understanding of the human experience and spiritual evolution. According to David Berceli, post-traumatic growth can open opportunities for wisdom as accessed through a transformation point once a traumatized individual returns to their "baseline." His belief is that "trauma appears to force the development of our evolving human potential," giving way to an evolution in our reflections, sensations, intuition, imagination, and stillness.[9] Similarly, Bessel van der Kolk's study of trauma highlights how various forms of therapy—from EMDR to yoga, meditation, and theater— are structures that "harness the extraordinary power of the imagination to transform the inner narratives that drive and

8. I capitalize the W in Work to emphasize the emotional labor that goes into self-work, and to give it value outside of the capitalist definition of work.
9. David Berceli, "Reframing the essential role of tremoring and/or shaking as a result of traumatic or stressful experiences," in online conference "Tracing Trauma: On the Science & Somatics of Healing Trauma," April 12–14, 2019. Available at https://www.embodied-philosophy.org/tracing-trauma.

confine our functioning in the world."[10] I believe that the collective consciousness that we are witnessing (or experiencing) now is an expression of healing, because if the healing work wasn't already underway, we wouldn't be reaching towards self-determination and liberation as nations, communities, and individuals.

This is particularly the case for people who have experienced intergenerational trauma and struggle, often from deeply rooted, marginalized, and colonized communities. I knew there were others coming to the same space of healing and deep inspiration through their reflections on struggle and self-care. One of my most influential teachers in this work is my mother. My mother, Sawsan Alsaraf, has been using art as a tool for her own spiritual growth since I was a small child. In the deepest struggles in our family lives, through grief, migration, and trauma, she always turned to art as a transformative practice, and a spiritual one too. I knew there was a scattered community of artists out there who were also engaged in powerful practices as a result of their own Work, using art as a tool to share the ancestral wisdom and deep self-reflection that I myself had accessed. Through the development of the exhibition *Take Care of Your Self* and this book, I soon started to recognize how notions of care, self-determination, empowerment, and healing were conceptually informing the work of artists dealing with complex issues of struggle both within my own community and in other communities along the margins.

I have come to realize that the self is only a part of the equation in the process of care and healing. I am still doing the Work, to maintain my practice and also to greet the shadow when it decides to come for a visit. I don't imagine a time in my life where that work will be completed, and that is a part of its legacy, my legacy. Sometimes it feels as though we are faced with one trauma only to be confronted by another one—or two, with barely any time to heal in between. I think of the women who came before me, my own ancestors, and the traumas that I

10. Bessel van der Kolk, *The Body Keeps the Score: Mind, Brain and Body in the Transformation of Trauma* (London: Penguin Books, 2015), 307.

"Al Asha Al Akhar," from the Sufi Path series / Sawsan Alsaraf /
Acrylic and mixed media on wood, 27" x 47" / 2014

inherited. However, I also think of the deep wisdom they gained through their hardships, and the tools they gathered for me to use. What a shame it would be to let their work go in vain. I think of my grandmother, Sajeda, while I write this, who taught us that *education is your weapon in life*. As an illiterate widow, she singlehandedly raised six children and put them all through university. I think of the people around me who don't have access to the tools and suffer silently. Taking this approach to care also challenges the stereotype that artists need to be troubled to make great art. Great art can also come from spaces of well-being and healing. Many artists themselves are empaths, and it becomes even more important for sensitive people to practice self-care to protect their mental well-being. I know that is always the case for me. The result of self-care should ultimately lead to more people being cared *for*: a shift from self-care to community care. If every person in our community practiced self-care, you better believe we'd all be taking care of each other, especially those of us who struggle with self-care. Sharing the tools of self-care is a community act, particularly in spaces where money is not exchanged and status is not regarded as currency or capital. This is evident in the many cities that have erupted in revolution against corruption and neoliberalism, from Beirut to Baghdad, where communities, both online and on the streets, create spaces of rest and care—from free concerts and outdoor movie screenings to widely shared "self-care guides" for protestors.

On Being Iraqi

In our gated, modern world, fault now gets deflected. Ruinous incursions such as Cuba, Vietnam, Iraq and Afghanistan are no longer assigned to one individual. Rather, we have, through a well-developed, propagandistic sleight-of-hand, made the people and places we attack responsible for our aggression.

—Thomas King, *The Inconvenient Indian*[11]

I am an Iraqi woman on Turtle Island coming to consciousness in the era of US-led wars and occupation against my homeland. This position has provided me with a particular perspective on representation and power, as well as self-determination and liberation. I write this with full awareness that I also occupy a position of privilege when it comes to class, race visibility, and mobility, particularly due to my life in diaspora. For most of my life, I have consumed the acute vilification of Iraqi people through North America's media machine. This is in stark contrast to the real-life stories of human suffering and survival I have access to through family and friends in Iraq and the diaspora. I see the destructive sociopolitical impacts of colonialism and imperialism on my own community. The far-reaching impact of war, occupation, forced displacement, corruption, and injustice manifest through untreated mental illnesses like post-traumatic stress disorder (PTSD), panic and anxiety disorders, and can lead to other physical illnesses.

During a visit to US-occupied Baghdad in 2004, a convoy of American tanks caused chaos on a strip of highway on our car ride home. I will never forget the panic that overtook my aunt, ducked down into the car, in hysteria, certain that we would be struck by tragedy. Where does that fear go? It stays in our bodies. My aunt suffered major digestive issues as a result of living through three wars in Iraq, sanctions, and US occupation. Finally leaving Iraq for the UK after being selected for

11. Thomas King, *The Inconvenient Indian: A Curious Account of Native People in North America* (Toronto: Doubleday Canada, 2017), 12.

relocation through the IOM (International Organization for Migration), she resumed some semblance of normal life, but was plagued with digestive issues until it turned into cancer. She lost the fight in 2019. May Allah have mercy on her soul.

My cousin was born during the Gulf War. One day in my grandmother's house in Baghdad, my uncle sneezed, one of those earth-shaking loud sneezes. Her seven-year-old self dropped her glass of water, which shattered on the floor. The combination of the bombastic sneeze and the sound of breaking glass plunged her into a state of shock, uncontrollably crying. Where do these memories live? Where can we file away trauma? Most importantly, when do we start to heal?

Since I embarked on writing this book, powerful revolutions have erupted in multiple countries around the world, from Lebanon, Sudan, Hong Kong, Algeria, Chile, Venezuela, Colombia, and the United States. The one closest to my heart is in Iraq, my motherland. What I have witnessed, through the buffer of my phone screen, is an unprecedented sociopolitical revolution centered on care, community, and culture. In my article, "Iraq is Healing: The October Revolution, Systemic Change and Intergenerational Trauma,"[12] I write about how the community of care that has emerged from within the heart of Iraq's October Revolution is a sign of deep healing. I wrote the article to bridge the gap between what was happening on the ground in Iraq and in the media apparatuses of the international community. The lack of media coverage was in stark contrast to the plethora of powerful content circulating from Iraqis on social media. I felt that the stories, the images, and the symbols of the revolution needed to be heard, seen, held, and celebrated because they have the potential to inspire all of our collective struggles. The October Revolution in Iraq was groundbreaking, because it exceeded the sectarian narrative that we have been fed throughout the years. The Iraqi narrative since

12. Sundus Abdul Hadi, "Iraq is Healing: The October Revolution, Systemic Change and Intergenerational Trauma," *Medium*, November 16, 2019, https://medium.com/@WATM/iraq-is-healing-the-october-revolution-systemic-change-and-intergenerational-trauma-2d8bc798901e.

the illegal US-led war and occupation in 2003—has been crafted by people who benefit from its instability and made it into a complicated mess that is difficult to articulate. Although there have been many protests in Iraq over the past decade, this time, however, it felt different.

On October 25, 2019, the people of Baghdad took over Tahrir Square, the highly symbolic center of the city, home to Jawad Salim's iconic *Nasb al-Hurriyah* (Freedom Monument). Their demands were simple: "*N'reed watan*" [We want a country]. They took to the streets to hold their government accountable for its defunct system. In one of the most oil-rich countries in the world (Iraq has the fifth largest oil fields in the world), the quality of life is devastatingly low. The unemployment rate is high. Poverty is extreme and the youth need jobs. Electricity is powered for five to eight hours per day, the water is contaminated, and there is a failing medical system. These are only a few of the issues Iraqis are frustrated with. Politicians never keep their promises. Restoration and service amelioration projects get squashed before the ink even dries, and the money allocated to them evaporates into dirty pockets. Iraq is currently caught in a tug-of-war between foreign powers invested in controlling its political and economic landscape, between the US, Iran, Turkey, Saudi Arabia, and others. Ultimately, the protestors wanted to break the system because it was already broken. The protests were peaceful, yet the government response was vicious. It has been reported that two thousand people were killed and over 27,000 injured during the October Revolution, which continued every day up until the coronavirus pandemic lockdown measures took hold in March 2020.

Iraq is a nation that has suffered widespread intergenerational trauma and pain. From Saddam's brutality, to the first Gulf War, the poverty caused by the UN's sanctions on Iraq, the "shock and awe" bombing campaign of the US' 2003 invasion of Iraq, the subsequent war and US occupation, the decade of civil war and militia control, to the ISIS chapter, there are tragic stories in every Iraqi. I have often been concerned for our mental well-being and the psychology of our nation as a whole.

Self-care is simply not championed in a society hardened by multiple wars and the militarization of everyday life. The October Revolution was a catalyst towards collective healing, a loud declaration that "Enough is enough. We deserve better!" The majority of the protestors were youth who had already lived through a lifetime of trauma. It's time to heal, both as individuals with the weight of the world on our shoulders, and as nations. On a social level, practicing and receiving widespread community care in the context of struggle is revolutionary in itself. We need to be at our full health and capacity to continue in our struggles, and to be victorious.

To paint a picture of some of the practices of care that were enacted in the streets of Baghdad, consider scenes of people distributing food and youth cleaning the streets. Imagine spending time at "Tahrir Beach" along the banks of the Tigris River, a public space carved out by Iraqi youth to encourage fellow protestors at Tahrir Square to go relax, play sports, watch an open-air movie, and hang out with friends. Think about the Cinema of the Revolution tent in Tahrir Square, where local independent films were screened, followed by discussions and live music. Witness the expressions of collective joy through dance, singing, and chanting. Feel the warmth in the act of people distributing blankets to the protestors on cold nights. Aside from the joyful energy, the protestors held space for the martyrs and the injured by organizing vigils and public funeral processions, lighting candles for the fallen, and setting up areas for prayer and ceremony.

Artists' transformation of the walls and spaces of the city was a major part of the revolution, creating an outdoor gallery of murals along the walls of the tunnel leading into Tahrir Square, now dubbed "the tunnel of art." Deep pockets of solidarity and community sprung up everywhere, from barbers offering their services to the protesters, pop-up libraries offering books, soccer matches, street poetry, even a lost and found tent. All of these acts of community care were offered by the people, for the people, for no charge.

Care workers set up tents on the ground, with doctors, medics, and volunteers. The brave boys and men who drive tuk-tuks

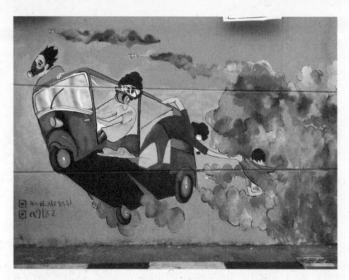

Mural by Yousif Aleqabi and Adel Alanzi, Tahrir Tunnel, Baghdad, November 2019
Photo by Amir Hazim

took on the role of being frontline rescue workers, transporting the injured to ambulances waiting for them, organizing a rescue system amidst the chaos of Tahrir square. Many tuk-tuk drivers protected their three-wheeled vehicles with wire, to keep the riders safe from tear gas canisters being shot at them. They are some of the bravest and most fearless Iraqis, and have become symbols of the revolution, with their unstoppable courage and unrelenting pride. Most importantly, they come from deep within the Iraqi struggle. Many of them, having lost parents in the various wars, learned to depend on themselves while trudging through poverty in a crooked system. During the revolution, many tuk-tuk drivers also refused any money for their services. One young tuk-tuk driver, Allawi, said to a journalist who offered to pay him for a ride to Tahrir Square, "Keep your money. I will take my rights from the government."

I choose to talk about this historic time in Iraq because I believe that the October Revolution is yet another flame to add to the collective consciousness sparking in the hearts

and minds of people engaged in the struggle, rooted in self-determination. Cultures that have long been represented and perceived as violent are proving to be cultures invested in care. From Iraq, to Palestine, to Chile, to Sudan, to Standing Rock, to Black America, and to all the struggles of the world, there is no shortage of beautiful acts of care that shine through the oppressive realities they are resisting. This is precisely the moment to bring to the forefront conversations on care, particularly for the people in the midst of struggle. In the struggle for basic rights, well-being should be one of them. These conversations have to be had in order to continue to persevere towards lasting liberation. There is something deeper brewing, and it has to do with *all* of us. It has to do with the deep impact of colonialism, imperialism, and corrupt systems disguised as democracy. It has to do with systemic change, from the inside out.

It is perhaps this position that enables me to connect to other communities that suffer the same symptoms, caused by the same disease: foreign entities claiming power over entire nations of people, rewriting history, and installing oppressive structures for us to stumble within. The military strategy of divide and conquer wants to see us at odds with one another, rather than in solidarity with one another. My intention here is not to generalize the diversity of struggles by equating them with my own, whether it be the struggle of the Indigenous people of Turtle Island or the occupation of Palestine. However, I want to draw a through line and make the connection that imperialist agendas and the impact of colonialism have greatly affected our communities, and caused intergenerational grief, loss, displacement, and trauma. The structures of racism and systemic oppression put in place by colonial powers are still very much present today. One needs only to look at the demographics of mental illness, incarceration, substance abuse, and poverty amongst various communities impacted by colonialism. I believe that decolonization is one of the antidotes to this experience and it comes in many different forms, depending on the communities affected. Part of this decolonizing work is care work; starting with the self and extending it into the community. Another aspect of

this work is through art practices and curating spaces for these methods to exist. I take it for granted that others in my position are tapped into the same knowledge and perspectives. I realize that there is still a lot of work to do in our various communities until we reach a point of self-determination and liberation.

New Word Order

Iraq has great geopolitical significance, as well as historic significance as the cradle of civilization, home to the earth's first known advanced civilization, the Sumerians. I believe that this land holds many keys to understanding our collective origin story, a history that has been continuously erased and systematically ignored. The word "Iraq" is said to be taken from the city name "Uruk," an ancient Sumerian city in the south of modern-day Iraq. Uruk is presumed to be the first city known to us, dating back to 4000 BC. *Uruk* is the root word for *A'reeq*, meaning ancient, majestic, pure, and deeply rooted. The plural, *A'raaq*, translates to *multiplicity of ethnicities*.[13]

Throughout the process of writing, I have struggled with having to use certain words prescribed to my experience by the English language. For example, *marginal* or *marginalized* literally translates to "of secondary or minor importance; not central." I do not subscribe to this description of my experience or my identity. Similarly, words like "people of color," despite being reclaimed in recent generations as an empowering term, still implicitly refer to whiteness, as do words like *visible minority*, *othered*, and *racialized*. If and when I do choose to use words like *marginalized, colonized,* or *racialized*, it is in reference to the *experience* of being marginalized, colonized, or racialized, a position that is of utmost importance and central to this book. In my quest to find an empowering word that I can identify the diversity of the international Indigenous, Black, Pan-African, Afro-descendent, Arab, Brown, Latinx, South American, and

13. With gratitude to my dear friend Zaineb Hasoon (Zee) for the brainstorm session that birthed this exploration.

Asian communities, I have come up short. This is an issue of subjectivity that is beyond semantics and vocabulary, because it implies that we cannot exist if not in relation to white supremacy.

Transcultural communities, in all our diversity, have much in common. However, to truly be in solidarity with one another, we must celebrate our differences rather than skim over them in an attempt to boast our similarities. Just as in a family, or a forest, each individual is completely different from the others, I see our interconnected communities as relatives. We are members of an international family with much to learn and teach one another, nurtured through a sophisticated system of roots. The experiences of struggle, unbelonging, colonialism, and marginalization has affected communities the world over, particularly when displaced and uprooted in so-called Western societies. Using as much care as I possibly can in broaching the subjects of identity, race, belonging, and discrimination, I have to tackle centuries-old paradigms of racial inequality and injustices based on the pigmentation of skin and otherness to European ancestry, rooted in the transatlantic slave trade, colonialism, and capitalism. How, then, can we see ourselves into the future? How can we honor our roots and ancestry in our acknowledgement of our plural identities? How can we define ourselves outside of the limits of the colonial construct while using the English language?

For this reason, I use the phrase *deeply rooted* in place of words that identify us as inferior, marginal, or secondary to whiteness. I use this word to describe the multiplicity of ethnicities who are connected not just through struggle, but through deeply rooted ancient identities, familiar spirits, and shared experiences of resistance to white supremacy and colonialism. The Lakota people have shared with the world the belief that "*Mitákuye Oyás'iŋ*" [we are all related]. This belief extends not only to the people of the world, but also to the land and all its creatures. As a collective consciousness towards liberation continues to grow within our scattered communities, spirituality is elevating us higher. Spirits are not bound by time or space. Allah created us all equal. We are the deeply rooted people, the A'raaq.

CHAPTER 2

DECOLONIZING CARE

On Care

In the spirit of Fanon and the opening chapter of *The Wretched of the Earth*, "On Violence," which speaks to the centrality of violence in colonization, I meditate here on care in the essential work of decolonization. We are now in the future world that *The Wretched of the Earth* gestures toward, yet not very much has changed from the world Fanon inhabited and described. In fact, the need for decolonization is now even more critical. Rereading the book in the context of the current wave of uprisings and the continuing struggles for liberation across the (ongoing) colonized world, the collective suffering seems greater and more overwhelming. Decolonization, Fanon writes, "which sets out to change the order of the world, is clearly an agenda for total disorder." He continues to say, "the colonized, who have made up their mind to make such an agenda into a driving force, have been prepared for violence from time immemorial."[1] Rooted in the knowledge that much of the colonized world has experienced a great deal of violence both by the hands of the colonizers and from their own corrupt governments, I ask: what is the opposite of violence?

1. Frantz Fanon, *The Wretched of the Earth* (Cape Town: Kwela Books, 2017), 3.

Experiencing violence, even as a witness to violence, creates a darkness that can quickly turn into trauma and mental illness. Dwelling in the place of darkness can be detrimental to our spiritual growth, our physical awareness, and our mental well-being. I've always been interested in contrasts. It's one of the ways my creative mind attempts to imagine alternate narratives to our experiences of violence, or war, or displacement, or loss, or colonialism; that is, struggle. If, as Achille Mbembe says, in the context of Fanon, "colonialism is a factory where madness is manufactured," then imagination is a factory where hope is manufactured.[2] If the counternarrative to violence is care, then that's where you'll find me.

In shifting the narrative of struggle from trauma and violence to care and liberation, much-needed radical transformations of self, community, and the world are possible. Growth happens in the light and in the shadows; there is so much potential in their exchange. The more we can define our struggles through care, the more our representations change, and the more our communities get empowered.

My particular interest lies in the politicization of care, particularly in the context of struggle. I'm interested in how care can become a tool in decolonizing our communities, and the potential of anticapitalist, decolonial approaches to care. In some cultures and societies, self-care simply isn't prioritized, at least not how many of us in the so-called West perceive it. Self-care has endless definitions, each one unique to the individual self and one's needs. This is where community care comes in. Ceremony, ritual, and community gathering become important practices, whether they are taking place in spiritual contexts, around kitchen tables, public spaces, or street corners. How can care be practiced in everyday contexts and in times of collective struggle, when trauma is so widespread, and care becomes an act of survival?

2. Achille Mbembe, "Frantz Fanon and the Politics of Viscerality," keynote address at "Frantz Fanon, Louis Mars, & New Directions in Comparative Psychiatry Workshop," Franklin Humanities Institute at Duke University, April 26–27, 2016, available at: https://www.youtube.com/watch?v=Ig_BEodNaEA&t=2989s.

Whether we are experiencing struggles for liberation on the frontlines or remotely, the collective witnessing of violence is all the more amplified by our social media feeds, often creating a sense of overwhelming grief and confusion. Spaces of self-care that are connected to the consciousness of people's everyday realities can become a necessary tool in remedying the oppression and sense of loss, particularly for deeply rooted people and those communities directly affected by race, class, and gender-based injustice. These spaces of care do not have to be confined to their intended contexts, either. Funerals, for example, can become sites of cross-cultural conversations on resistance and change, as with Muhammad Ali's memorial service and Nipsey Hussle's funeral procession. Muhammad Ali's legacy in life and death was founded on transcultural solidarity and the struggle for liberation, and his carefully planned memorial service created a space for these conversations to continue to grow. (I write about this in more depth in Chapter 3, in the section "Me, We, Muhammad Ali.") Nipsey Hussle, born Ermias Asghedom, was killed by gun violence at age thirty-three after building his career as a hip-hop artist and entrepreneur. He was a positive community leader focused on social equity who cared for and empowered his community. In both cases, their funerals became an opportunity to create transformative conversations for the communities directly affected by their loss, as well as a much wider community tuning in and grieving from afar. Traumatic global events, though rooted in loss and grief, can also make way for collective healing and systemic change, such as the call to abolish the police.

We talk about the need for social change the world over to address the ongoing violence of capitalism, patriarchy, colonialism, white supremacy, and their far-reaching intergenerational traumatic impact on our communities. Yet the opportunities to discuss and find meaningful practices for collective healing are few and far between, although they do exist, in moments surrounding crisis or tragedy. If we don't imagine different systems and ways of being, we'll continue circling back to the symptoms. The simultaneous uprisings happening around the world are creating powerful new conversations on transcultural

solidarity, decolonization, and systemic change. They are offering opportunities to adapt our habits—and our systems—to a more sustainable future, one that is centered on care and social equity.

Capitalism doesn't champion the idea that self-care is accessible to all, and that care for our planet is a catalyst towards healing the climate crisis. Patriarchy doesn't make visible the labor and wisdom of the women-identified elders in our community, which is often centered on care. Colonialism doesn't champion the voices and achievements of colonized people and their contributions to revolutionary thought. Imperialism doesn't champion the movements of counterculture and art that has the potential to inspire generations towards positive change. None of these systems consider that well-being, mental health, and healing from the trauma often caused by their impact are human rights. For many deeply rooted communities, systemic change means returning to and healing with our ancestral knowledge, the very knowledge that the current systems in place try to continuously suppress or erase.

On Teachers

I believe that the collective witnessing of structural violence during recent decades has reawakened the concept of "self-care." The term has reached critical mass since the beginning of the coronavirus pandemic in the spring of 2020. One of the most heavily quoted statements on self-care within radical, racialized, and marginalized communities happens to be by Black-queer-feminist poet, Audre Lorde. While battling cancer in 1988, she wrote: "caring for myself is not self-indulgence, it is self-preservation, and that is an act of political warfare."[3] For decades Lorde championed the notion of self-care and made it political and spiritual. My starting point when thinking about the term "care" is the work of Black feminists such as Lorde, who have done the tireless work of critically unpacking what it means

3. Audre Lorde and Sonia Sanchez, *A Burst of Light: And Other Essays* (Mineola, NY: Ixia Press, 2017).

to truly "take care of yourself" in the context of transcultural struggle and community. Patricia Hill Collins writes about this specific context:

> the existence of Black Feminist thought suggests there is always choice, and power to act, no matter how bleak the situation may be. . . . While individual empowerment is key, only collective action can effectively generate the lasting institutional transformation required for social justice.[4]

Women of color make up a tiny minority of academia and the arts. As an Iraqi woman and artist engaged in care-work, social justice, and empowerment, it is important for me to reference other women of color who have paved the path I find myself on. I see great value in the contributions of Black writers such as Audre Lorde, June Jordan, Angela Davis, and bell hooks, whose texts are foundational to the discourse and practice of care in the context of struggle—one that is grounded in individuals, communities, and social movements.

I have always been drawn to the liberatory work of figures like Malcolm X, Edward Said, Frantz Fanon, Muhammad Ali, Suheir Hammad, Emily Jacir, Thomas King, the Prophet Muhammad, and my own father Taghlib. The Prophet Muhammad is in a category of his own, holding within me a space of great reverence and inspiration. Malcolm X spoke truth to power through his faith and spirit, steadfast in his belief in justice and spiritual knowledge, empowering generations upon generations. Muhammad Ali's memorial service in 2015 is the foundation to this very book, a show of transcultural solidarity among all peoples united in struggle. Edward Said completely changed the narrative around representation, particularly for those marginalized by colonialism, and gave us the tools to articulate it—that's care. Many of Frantz Fanon's writings about decolonization ring true today, and the seeds he planted in the revolutionary movements of the sixties are now trees that continue to bear fruit. Suheir Hammad was the first Arab woman I

4. Patricia Hill Collins, *Black Feminist Thought: Knowledge, Consciousness, and the Politics of Empowerment* (New York: Routledge, 2015), 309.

saw hold a mic and sew sequins of truth, like this gem from her poem "What I Will":

I will not side with you nor dance to bombs
because everyone else is
dancing. Everyone can be
wrong.[5]

Emily Jacir weaved care and community into her artistic practice during some of the most hostile eras for a Palestinian artist in the arts industry. Her precursory work in this field has paved the very path I am on. Thomas King made accessible the great injustices of settler violence against the First Peoples of Turtle Island in a society that has systematically made this history inaccessible. My father Taghlib, whose struggle and resilience I've witnessed since birth, has taught me so much about standing firm in the face of corruption. These figures, among many unmentioned others, have been foundational to the development of my identity as an artist, writer, and critical thinker. They embody this book as well, with its emphasis on spirit, knowledge, care, accessibility, decolonization, resilience, representation, justice, and solidarity. Ultimately, these figures spoke truth to power, changing the narrative through free and critical thinking in the struggle for liberation.

Imagination is the language of many artists, writers, and storytellers. Robin Wall Kimmerer said, "Imagination is one of our most powerful tools. What we imagine, we can become."[6] Kimmerer writes this in *Braiding Sweetgrass: Indigenous Wisdom, Scientific Knowledge and the Teaching of Plants*, with its many lessons from the plant world and our ancestral roots to learn from. In fact, these two teachings—earthly and ancestral—are very much intertwined. When Kimmerer writes about the living Indigenous traditions of Turtle Island, I am able to draw significant parallels with my own kinfolk in Iraq and with many

5. Suheir Hammad, *ZaatarDiva* (New York: Cypher, 2005), 60.
6. Robin Wall Kimmerer, *Braiding Sweetgrass: Indigenous Wisdom, Scientific Knowledge and the Teachings of Plants* (Minneapolis: Milkweed Editions, 2014), 184.

Indigenous traditions across the world: from Palestine, to the Amazigh, to the Pacific Islands. This is decolonization in action.

Kimmerer details a relationship with care that I previously took for granted: that well-being in our individual lives and communities is not only a necessity for people, particularly those who have experienced the intergenerational impact of colonialism, but also for the land, which takes care of us. This is, by necessity, a reciprocal relationship. Kimmerer also gently suggests that our current way of life, based on overconsumption of natural resources—from food to medicine to energy—is unsustainable. However, she offers wisdom and guidance as to how we can correct our habits, starting with gratitude. Gratitude is a practice I am extremely familiar with, rooted in the oft-spoken Arabic word, *Al Hamdulilah*—which translates to the phrase: "All Praise and Thanks be to Allah." It is an expression of gratitude spoken at any and every occasion that invites gratitude, even (and especially) in hardship. My favorite chapter in Kimmerer's book is dedicated to the Haudenosaunee Thanksgiving Address, a traditional invocation that expresses gratitude for life and care for the world. Of the Address, translated here as "The Words That Come Before All Else," she writes:

> while expressing gratitude seems innocent enough, it is a revolutionary idea. In a consumer society, contentment is a radical proposition. Recognizing abundance rather than scarcity undermines an economy that thrives by creating unmet desires. Gratitude cultivates an ethic of fullness, but the economy needs emptiness. The Thanksgiving Address reminds you that you already have everything you need. Gratitude doesn't send you out shopping to find satisfaction; it comes as a gift rather than a commodity, subverting the foundation of the whole economy. That's good medicine for land and people alike.[7]

Al Hamdulilah.

7. Kimmerer, *Braiding Sweetgrass*, 107, 111.

Approach with Caution

I struggle with the term self-care. It's a beautiful intention, but it's been so coopted by its hashtag counterpart and corporate marketing machines. I find it difficult to deal with the capitalist aspect of self-care. Self-care in our societies often comes with a hefty price tag, making the services and spaces of well-being practices inaccessible and unwelcoming for those who can't afford it. Whether it is membership to a yoga studio, massage sessions, traditional or holistic therapy, energy healing, or Reiki, the realities of access come only to the privileged few, because ultimately in a commodity society, the practitioners have to get paid for their services in order to continue to offer them. It's a vicious cycle that only some practitioners are willing to break through by offering sliding scale or community rates in order to be more inclusive to patients or clients with low incomes or other difficulties. One of the biggest critiques of self-care is that the ones who need to practice self-care the most—those struggling with class exploitation and economic injustices and oppressions deeply connected to race, ability, and gender—cannot afford the services of self-care.

I never thought I'd write a book about self-care. It's not my "thing." I'm an artist, curator, and storyteller. I am sure there are many people better versed in the self-care oeuvre than I am. At this point, I have self-care exhaustion. The term has become so overused and commodified that it's lost much of its significance to me. Since I started to write this book, I've been bombarded by self-care sponsored ads on my Instagram account to the point that I feel I'm being surveilled by Big Brother's algorithm. Self-care memes and quotes follow me through the people I follow and the people I don't. They're everywhere I look. It makes me want to throw my phone away and practice self-care the way I learned to do it before I needed to be reminded by my phone. In fact, the smartphone is a big part of the problem; not just for me, but for our entire connected world, feigning connection, addicted to information fed to us through our screens. Writing about self-care today sometimes makes me feel like I'm a part of a trend that may disappear as quickly as it came.

When I first started thinking about self-care, it was an organic, solitary process. A spiritual one. I had to read, research, dig, and make connections, in real life, to healers and guides along the way. There was no hashtag and social media culture surrounding it. Part of me thinks it's a great step in the right direction: if more people are aware of self-care and healing, then it's wonderful, right? But I'm skeptical. It all feels a bit. . . manufactured. From the sage that I burn, to the yoga I do, I wonder how the sacredness of these practices has become commodified and appropriated, and how I am contributing to that. Studies have shown that the over-harvesting and sale of white sage and Palo Santo are causing these sacred herbs and trees to become endangered, and the Indigenous communities from which they originate to bear the weight of their loss. And so, self-care can start coming with a bit of guilt, or perhaps a sense of hypocrisy, if you're self-aware enough to recognize it.

A good question to ask then is, how do my acts of self-care impact other communities whom I may borrow from or whose wisdom has served me? How am I contributing to spiritual appropriation that can be harmful to the communities from which they originate? How, in return, can I give back to those communities to keep a cycle of care alive? Living in settler-colonial North America, many of us benefit from a range of overlapping privileges, whether we are white, white-passing, or non-Indigenous people of color. Even marginalized groups can cause harm to other marginalized groups. What are we doing with that privilege? How do we balance out what we take with what we give? One of the ways I have learnt to be more self-aware when it comes to my own practice of self-care is to be conscious of the historical injustices that are linked to the cultures from which certain popular self-care rituals originate. Better yet, I consciously choose to look into my own culture, spiritual beliefs, and ancestry for guidance on self-care practices that have been passed down through the generations, oftentimes lost but always looking to be found again.

The pervasive need for healing is palpable in our current interconnected world. Despite my skepticism, I have to admit that

I feel that we are moving towards a collective consciousness that is undeniable, and I hope that to be true in real life, outside of the algorithms that feed themed information into our screens. Spiritual growth, the act of sharing sacred knowledge, and accessing ancestral tools for self-care at this rate and pace are a phenomenon only possible through technology, and for that I am grateful, but also cautious.

The Role of the Artist

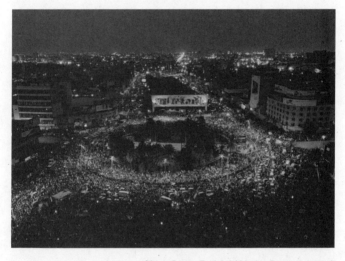

Tahrir Square, Baghdad (October Revolution, 2019)
Photo by Ghaith Abdulahad

One writes out of one thing only—one's own experience. Everything depends on how relentlessly one forces from this experience the last drop, sweet or bitter, it can possibly give. This is the only real concern of the artist, to recreate out of the disorder of life that order which is art.

—James Baldwin, *Notes of a Native Son*[8]

8. James Baldwin, *Notes of a Native Son* (Boston: Beacon Press, 2012), 7.

The role of the artist is, in times of crisis, in times of stability, and in resistance, one of the most important responsibilities in society. An artist, when independent of the state and corporate affiliations and dependencies, occupies a very important socio-cultural position. Armed with free and critical thinking, artists can craft new narratives and forge new connections outside of the spheres of national identity and official history. This is a responsibility that many artists take very seriously. As Edward Said writes in *Culture and Imperialism*:

> In a totally new way in Western culture, the interventions of non-European artists and scholars cannot be dismissed or silenced, and these interventions are not only an integral part of a political movement, but in many ways the movement's *successfully* guiding imagination, intellectual and figurative energy reseeing and rethinking the terrain common to whites and non-whites. For natives to want to lay claim to that terrain is, for many Westerners, an intolerable effrontery, for them actually to repossess it unthinkable.[9]

The role of art in liberation movements has a rich history, although you will rarely find it in mainstream museums or included in art history curriculums in most classrooms. From Black America, to Palestine, to Iraq, and in much of the colonized world, artists straddle the worlds of art and politics to record and reinterpret struggles through their own vision. This role is not only relegated to visual artists, but to writers, musicians, filmmakers, photographers, dancers, and playwrights as well. Artists can make such a great sociocultural impact that they can sometimes present a threat to the powers that be. Palestinian political cartoonist Naji Al Ali, for example, created an icon of the Palestinian struggle through the creation of his character Handala. His cartoons carried so much power that he was assassinated in 1987 outside his workplace in London. The assassination was never investigated.

Baghdad Group for Modern Art was founded in 1951 by one of Iraq's most influential artists, Jewad Salim. Their manifesto

9. Edward Said, *Culture and Imperialism* (London: Vintage, 2007), 212.

from a 1951 exhibition by the group states that the artist has a "duty to interpret society by depicting current events and recording the social conditions of the country." This statement has had a far greater impact on my practice than anything I've come across in the Western canon. I believe that the impact of the Baghdad Group for Modern Art can be felt in many contemporary artistic and cultural communities in Iraq and in the greater Arab world. It is especially being revived now as a result of the October Revolution. Salim's final artwork was the iconic *Nasb Al Hurriya*, a massive bas-relief mural located in Tahrir Square in Baghdad, the site of the October Revolution and previous uprisings as well. In fact, the monument was commissioned in 1959 by the Iraqi military regime of Abdel Karim Qasim to commemorate the one-year anniversary of the July 14th Revolution, which marked Iraqi independence from British colonial rule. The monument is unfinished—Salim died of a heart attack while completing the work. Salim conceptualized it as "twenty-five interconnected figures, representing a visual narrative of the revolution and the events surrounding it," as described by Nada Shabout in *Modern Arab Art: Formation of Arab Aesthetics*.[10] Stylistically, the work references Arabic calligraphy (to be read from right to left), Sumerian and Babylonian motif inspiration, as well as influences from Western art. Salim's vision of incorporating iconography and aesthetics from the ancient Mesopotamian civilization was groundbreaking at a time when most artists, himself included, studied art in Western institutions outside of Iraq, in the Western "style." To give value and make accessible the art of his ancestors is, in my opinion, a decolonial approach to art-making, during and soon after the British colonial rule and its de facto administration ended in Iraq. Fast-forward to today, the role of art and artists in the October Revolution played a significant role in Iraq, under Salim's *Nasb Al Hurriya*'s watchful eyes, with many murals and artworks referencing the monument as both the symbol and site of the revolution.

10. Nada M. Shabout, *Modern Arab Art: Formation of Arab Aesthetics* (Gainesville: University Press of Florida, 2015), 27–29.

Artists, for generations, have found themselves on the frontlines of the struggle for liberation. Driven by the people's stories (and their own), many artists have engaged with the concepts of community care and empowerment. Freedom of expression becomes something worth fighting for. It is no surprise that many of the youth assassinated, kidnapped, or jailed during the October Revolution in Iraq were artists, photographers, and poets. For those who were spared death, I wonder, how is their mental health doing? Does anyone ask this question? How about the artists whose work is deeply involved in struggle, both personal and political? What are the systems put in place to support the well-being of these young artists, writers, and cultural producers?

I believe that part of this healing work can happen through the creation of safe spaces to convene in the presence of art and community, engaged in conversations on decolonization, self-care, and empowerment and with care at its core. My contribution to this growing movement of care in the context of struggle is rooted in the transformative power of art and culture. My hope is that through the care-full curation of art and space, the heavy subjects of trauma, loss, and displacement can transform into opportunities for healing and empowerment. Most importantly, I hope that the artists whose work graces the pages of this book can illuminate the concepts of art, care, and struggle I have elaborated thus far.

Suheir Hammad
@yosuheirhammad

wish you deep healing from all trauma
& wish that you don't traumatize others

#bossa

9:46 AM - 26 Feb 2019

CHAPTER 3

DECOLONIZING THE ART WORLD

We Are The Medium

As a deeply rooted artist practicing for over a decade, I have come to know and collaborate with a most welcoming, beautiful, and diverse community of likeminded artists with similar yet different experiences of struggle. It wasn't always like that, and getting there I followed a very organic and winding learning curve, with many experiences that were not so welcoming, beautiful, or diverse. Being an independent artist with no gallery representation meant that the margins were home. It is in these margins that I learned how to depend on my (our) own skills to organize and create the projects we wanted to make. Being a non-white independent artist in an industry that can have rigid power structures that favor white privilege gave way to many difficult encounters with the gatekeepers of major institutions and art spaces. Museums and galleries are not the safest places—in fact, they can be downright traumatizing, not only in content but also in their interactions with artists.

In my own practice, I have been pigeonholed as a diasporic Iraqi artist, and for many years, my work only fit under the

sensationalist curatorial umbrella of the war/trauma/refugee discourse. Interactions with gallerists and curators were rarely "caring"—most of the time, they were downright scathing, like when a prominent gallerist returned my work after receiving it, claiming it to be "disappointing and unloved." My work has been misrepresented in the media, censored by a major European art institution, and was even once labeled as contraband in a Gulf country. I've had to turn down offers for projects that had funding from sources that I do not align with ethically or politically. In the rare cases where we are granted entry to major institutions and spaces, we must take and claim that space but play by their rules. When that door is locked shut, we must carve out our own space along the margins. It is in that space that I have found care and community. Once, while complaining about all the bad experiences I've endured as an artist to a friend in the industry, he responded by urging me to let them go. He said: "Don't let these negative experiences define you as an artist. Focus on the positive and you will start seeing all of your accomplishments more clearly." At first, I thought he was being dismissive, until I realized that I was hurting my own career by becoming jaded by the industry. That realization was a wake-up call that I was in the wrong fight, and the best antidote was to stop seeking validation, and rather, create opportunities for care in an industry that suffers from a lack of it.

In 2012, I cofounded We Are The Medium, an artist collective and culture point for publishing, media, and the arts, alongside my partner Yassin "Narcy" Alsalman. The collective is comprised of independent artists working with various media—from photography, to music, to film. We are a tribe connected through family and art. Representation, new narratives, storytelling, and internationality are some of the common threads that link our projects, artwork, and curated events. We serve the community of the margins: deeply rooted, displaced, diasporic, undefinable. Our belief is that *the minority is really the majority*, and we align and collaborate with others who share the same values for cultural impact as we do. Through the collective, I have independently curated a number of exhibitions

and events.[1] As an artist-curator, I draw from my experiences as an exhibiting artist, reflecting on all the times I have been disrespected, misrepresented, and undervalued. My approach to curation has everything to do with how I want to be treated as an artist participant in a group show: respected, represented, and valued. Curating on my own terms contributes to personal empowerment and self-determination throughout the process. The terms are organic and depend on the project, but generally it is seeing a vision through from A–Z, working alongside artists to facilitate how they envision their participation, and creating an atmosphere that is not stressful, but caring. It is empowering to shed myself of structural limitations set by cultural or funding institutions, that often use our stories to enhance their preexisting status as cultural institutions and to fill quotas and agendas.

However, complete institutional independence also presents many challenges, from sourcing funding to securing spaces for exhibits. Administrative work often eats up the majority of time that could otherwise be spent creating. Much of the time, we sacrifice our salaries to be able to make meaningful projects that can be accessible and free for the public, not to mention the commitment of friends and allies who offer their services and work for little or no compensation. It takes a village, a community, to run independent projects.

The Industry

Museums and art institutions often uphold colonial narratives and occupy an authoritative position in the writing of history. Due to the history of colonialism, systemic oppression, and misrepresentation of deeply rooted communities, discrimination and tokenization are real issues when it comes to how curators choose to represent artists, often sensationalizing traumatic histories and personal struggles, or omitting them. It is

1. For instance, "Arab Winter" in 2012 and "Ink Tank: Prints from the Arab World" in 2014. For more on both, see http://www.wearethemedium.com.

no secret that the art industry has very few people of color in the ranks—as well as on the walls—of major art institutions. Sexism and discrimination in the art industry has been made visible by activist-artists such as the Guerilla Girls for decades (and ongoing), and curatorial activism has recently entered the discourse thanks to books like *Curatorial Activism: Towards an Ethics of Curating* by Maura Reilly. As Guerilla Girl Donna Kaz writes in *PUSH/PUSHBACK*, "You do not have to be a statistician to get information. Today the information is even more readily out there—online and at your fingertips. Take a minute and look for it. Memorize it and have it ready to roar when people question the existence of sexism or discrimination."[2]

I've always disliked visiting art institutions, because the lack of representation was all I could see. Instead of marveling over Picassos or Michelangelos at the Louvre, my favorite moment at a museum was at the Museum of Modern Art in Baghdad, where I finally came face-to-face with artworks by the Iraqi "Pioneers" (or *Ruwwad*) that I've only ever seen in my parents' books. In the West, rarely would I come across an exhibit of Black and Indigenous artists, such as the unforgettable time I happened upon an Emory Douglas and Richard Bell exhibition at the Campbelltown Arts Centre in Sydney, Australia in 2011. I experienced similar Eurocentric fatigue during my Art History studies.

When I finally took the Art History 200 class in my last year of undergraduate study, it was taught by a different professor. She still skipped the chapters on African, Islamic, and Ancient Egyptian art. When I asked her why, she responded: "I simply don't know enough about them to teach it." This points to a systemic issue in the field of art. White supremacy, white privilege, and Eurocentrism still define the arts industry, and often set the standard for international industries too. This is why taking a decolonial approach in this field is so important. In her book *Curatorial Activism*, Maura Reilly writes, "Exclusionary

2. Donna Kaz, *PUSH/PUSHBACK—9 Steps to Make a Difference with Activism and Art (because the world's gone bananas)*, self-pub., ibooks, 2019, https://guerrillagirlsontour.com/push-pushback-guerrilla-girls.

practices against non-white artists are visible everywhere in the art world—in the art galleries, museums, press, market, exhibitions, permanent collections and so forth."[3] Reilly mostly covers major art exhibitions in the United States and Europe in her book, and admits that her own identity as a white woman from the US informs the book's selection of exhibits.[4] There is still so much work to be done, as artists, curators, teachers, and industry folks in general, to decolonize art spaces and make them less discriminatory and triggering for deeply rooted communities.

Breaking Down the Walls

Rarely can museums and galleries become sites of healing. Due to many museums' historical complicity in colonialism with their erasure and exclusion of non-white artists, this is still a very tricky situation. I have found that African-American artists Simone Leigh and Solange Knowles have managed to create caring yet critical spaces within major art institutions, that are not divorced from the struggle of Black people in America. Simone Leigh transformed the New Museum in New York City into a space of self-care through her 2016 exhibit "The Waiting Room." The project was inspired by the death of Esmin Elizabeth Green, a forty-nine-year-old African-American woman who died in a Brooklyn hospital after spending twenty-four hours in the waiting room in 2008. The project is both a commentary on the American medical industry as well as a project that aims to "heal Black women's pain" with a series of workshops, lectures, and events that promote self-care. Although the most recent manifestation of Leigh's project happened in a major art institution, she managed to create community spaces by doing "underground" events that were free of charge outside of the opening hours of the museum. The "Care Sessions" included a guided meditation for Black

3. Maura Reilly, *Curatorial Activism: Towards an Ethics of Curating* (London: Thames & Hudson, 2018), 103.

4. Reilly, *Curatorial Activism*, 15.

Lives Matter, Afrocentering, massage, community acupuncture, and herbalism workshops. In the curatorial statement, the artist suggests, "creating a space for wellness may require both the making of a sanctuary and an act of disobedience against the systemic enactment and repudiation of black pain."[5] In this instance, she transformed the formal museum space into a more open and caring place.

Solange Knowles, a polymath artist, presented her masterful performance piece "An Ode To" at the Guggenheim Museum in New York City in 2017. The performance, which involved "100 black bodies and a horn section," included "movement, installation, and experimentation with reconstructed musical arrangement, composed and conceptualized by Solange."[6] Solange approached the Guggenheim herself with the proposal for the performance, an interesting shift in power dynamics as the norm is for the museum to invite artists into their space. With the museum's admittedly poor record of giving space to women of color (the first solo exhibition by a Black woman artist, Carrie Mae Weems, was in 2013, and the first Black curator, Ashley James, was hired in 2019), Solange chose wisely and purposefully. The album that the performance was centered around, *A Seat at the Table*, is very much about the reclaiming of Black stories, narratives and spaces, with an emphasis on self-care. To end her performance, Solange said to the audience:

> Hold your communities tight. That's why I'm here. I care about seeing your faces in this light. I don't care much about the institutions. I care about having the show to see the faces that I wrote this album for. . . . I'm not settling for being allowed in these spaces but for tearing these fucking walls down. Inclusion is not enough. Allowance is not enough. We belong here. We built this shit.[7]

5. Simone Leigh, "Simone Leigh: The Waiting Room," New Museum of Contemporary Art, New York City, June 22, 2016–September 18, 2016, https://www.newmuseum.org/exhibitions/view/simone-leigh-the-waiting-room.

6. Cady Lang, "8 Things to Know About Solange's Super Secret Guggenheim Performance," *Time*, May 19, 2017, https://time.com/4786319/solange-guggenheim-performance/.

7. Lang, "8 Things to Know About Solange's Super Secret Guggenheim Performance."

The project's name, "An Ode To," is taken from the track title "Borderline (An Ode to Self Care)" off of Solange's album, *A Seat at the Table*. The song itself is about the politicization of self-care—I've quoted parts of the lyrics at the opening of Chapter Five, "On Space." Artists of color have been, for generations, actively engaged with this process of care and empowerment, particularly in the context of systemic oppression. To bring one hundred Black bodies into an institution that has systematically excluded that very experience is revolutionary in its approach, especially when empowerment is at the core of the work.

The problems behind terminology related to race and class makes decolonizing work all the more complex and necessary. As mentioned in Chapter 1 in "New Word Order," a lot of the words we use to reclaim our identities in the context of oppression, such as *marginalized, colonized, racialized, people of color* imply subjugation to white power. What if we stopped using these words? What if the language around identity took a different form? We have to ask ourselves difficult questions in order to dismantle the colonial constructs that have permeated every aspect of our social, political, cultural, and economic understanding. The questions start with the self, then move out into society, and then into the world.

In decolonizing work, oftentimes the words we choose to identify with, the mediums we choose to express ourselves, and the language we speak to spread our messages of resistance are products of colonialism. Of this phenomenon, Said writes: "That is the partial tragedy of resistance, that it must to a certain degree work to recover forms already established or at least influenced or infiltrated by the culture of empire."[8] Unfortunately, the institutions that make accessible the groundbreaking decolonizing work that I have covered are often complicit in its silencing and exclusion as well. It is a double-edged sword: to be able to establish oneself as an artist that is valued by the industry, and then break down its walls, one must first get that "seat at the table." What about when the seat never frees up for

8. Edward Said, *Culture and Imperialism*, (London: Vintage, 2007), 210.

you? Where do we sit then? I believe that there is great value in independent projects, ones that don't rely on the support or validation of a major institution. Eventually, when one goes at it for long enough outside of the so-called industry, people will start asking to sit at the new table.

Interventions

Someone once said that behind every conscious man is a tired Black feminist. This is a letter to my ride or die sisters, an ode or a love poem, a thank you note towards the women who have lit themselves on fire so that we might find our way.

—Teeanna Munro, untitled poem[9]

Art and community interventions can take multiple forms. Effecting ruptures in the daily lives of people—creating unexpected breaks from the usual routines—can transform negative emotions and effect real change. These artistic ruptures present opportunities to transform what may be broken or fleeting into productive, reflective, and poetic encounters. For many women of color, convening and staging such interventions in each other's lives have always been part of the fabric of their lives and communities. These encounters take place in the home, on the phone, or are sometimes organized into public interventions, workshops, or art projects. As Patricia Hill Collins writes, "Black women's actions in the struggle for group survival suggest a vision of community that stands in opposition to that extant in the dominant culture. . . Afrocentric models of community stress connections, caring, and personal accountability."[10] This is also palpable among Iraqi women who participated in community care during the October Revolution in Iraq, and we can certainly extend this description to include women from other deeply rooted cultures who are engaged in struggles for liberation.

9. Full poem on page 104.
10. Patricia Hill Collins, *Black Feminist Thought: Knowledge, Consciousness, and the Politics of Empowerment* (New York: Routledge, 2015).

In the context of struggle, loss is a stark reality. The grief experienced by mothers, family, and community members connected to victims of structural violence requires its own space for healing. Between 2011–2014, social practice artist Arielle Julia Brown founded "The Love Balm Project," a theater of testimony workshop series that later evolved into multiple iterations of public and site-specific performances. "Love Balm for my SpiritChild: Testimonies of Healing Justice Through Mothers' Memory" is rooted in the Black communities in San Francisco's Bay Area and Atlanta, and Brown's experience witnessing collective memory in Rwanda by women impacted by the Tutsi Genocide. The project was initiated with the belief that commemoration and memory can act as "conduits of justice" in the experience of loss and healing, particularly for—and through—grieving mothers.[11] Brown started by collecting the personal testimony of her godmother, Bonnie Johnson, after her grandson Oscar Grant III was shot and killed by a police officer in Oakland in 2009, and invited other mothers/collaborators who had lost children to systematic violence and police brutality. The collaborators of the project and workshops were "mothers in the community who identify with having been affected by the murder of personal and communal children." The four-part workshop series "created the space and creative framework for the (six) women to construct their testimonies grounded in their own lived physical, spiritual, and activist-inspired memories."[12] The first series concluded with a reading of the mothers' testimonies at a theater in Atlanta in 2011. In the project's manifesto, Brown describes the workshop activities including "creative writing, the reading of testimonies and monologues, performance building and constructive dialogue." Ultimately, the goal of this project was to create spaces to grieve and heal, using the power of mothers' memory as a "political/spiritual/creative force."[13]

11. Arielle Julia Brown, "Love Balm for my SpiritChild" in *Revolutionary Mothering: Love on the Front Lines*, ed. Alexis Pauline Gumbs, China Martens, and Mai'a Williams (Oakland: PM Press, 2016), 207.

12. Arielle Julia Brown, "Love Balm for my SpiritChild," 204–213.

13. Arielle Julia Brown, "Love Balm for my SpiritChild," 213.

Staging such a project creates both a safer space for healing as well as a counternarrative in the ongoing struggle against police brutality in the Black community in the United States. A mother's grief is undeniably the most universal humanizing pain, and rarely is a grieving mother's narrative represented fully in the murders of their children by police officers or soldiers. Alone it can sober the world and cause revolutions, as proven by Emmett Till's mother Mamie Elizabeth Till-Mobley's decision to call mourners to an open casket funeral after her son's gruesome lynching in 1955. The labor and grief of women of color in our communities is often rendered invisible by the mainstream media in our patriarchal societies. This has influenced my own curatorial approach with regard to the creation of a safer space, the centering of narratives of women of color, and the act of collective grieving leading to collective healing.

During the Black Lives Matters protests in the summer of 2020, artist April Banks—along with archivist/storyteller Arianne Edmonds and healing justice advocate Alli Simon—staged an intervention for collective grieving on the shores of what is called the "Inkwell," a two-block area of Ocean Park beach in Santa Monica relegated to the Black community during the Jim Crow era. Banks invited people to mourn and meditate in honor of the lives of those lost due to the pandemic and the lives of Black people lost to systematic violence. The first sunrise meditation brought together almost one hundred people in a ceremonial gathering for collective grieving. Participants were all dressed in white, wearing protective face masks, holding flowers as offerings. The ceremony involved a physically distanced walking meditation towards the shore, followed by a guided meditation by Alli Simon. During a time of heightened grief and isolation due to both the coronavirus pandemic and the murder of George Floyd, this intervention brought people together to grieve, heal, and hold space for one another and for the deceased. Banks described the intentions behind the gathering on her social media:

Grieve Together, Heal Together / *TCOYS* Poster

Our intention for this sunrise mourning meditation was to provide a safe space to grieve collectively. To gather at a little known historically Black place. From the ritual to mourn *MAAFA* (Kiswahili for a 'terrible occurrence' which names the massive loss of life in the transatlantic middle passage) we gifted flowers to the ocean, in honor of all those we have lost to police brutality and the coronavirus. To bear witness to one another's grief is revolutionary. To rest is revolutionary. To be vulnerable in public is revolutionary. We need healing, a moment to breathe, in this everlasting fight.[14]

Ameen. May the grief be soothed, and the hardships be met with ease.

I am also interested in how acts of care enacted by women take place in the public sphere, far removed from the art

14. April Banks, @teaafar (instagram), accessed August 17, 2020, https://www.instagram.com/p/CBGeeT9BTzr/.

world. When the October Revolution broke out in Iraq in 2019, women took a central role in bringing care into public spaces, such as Tahrir Square. A viral video shot on the first day of the revolution shows Dunya, a woman known to sell packets of tissues on the street for a living, frantically distributing her tissues, her livelihood, to the protestors struggling with tear-gas fumes. She became a symbol of the revolution. I reflect back on scenes of mothers and their children cooking giant-sized meals in the heart of Tahrir Square, baking bread and distributing food and water to the protestors every day and night. I think of Alia, the young woman who organized a cleaning crew to remove the trash and beautify the streets, armed with rubber boots and gloves. Two mothers set up a mobile laundry service, offering to wash protestors' clothes. There were women, of all ages and backgrounds, documenting, chanting, praying, tending to the injured, and accompanying teenage sons participating in the revolution. A powerful photograph I will always remember shows an adult man laying on his mother's lap on the sidewalk of the Tahrir tunnel, both smiling widely. The caption on the viral Instagram image read: "This protestor texted his mother and told her he missed her after a week away from home, and so she came down to Tahrir to see him. The moment he saw her, he laid down in her lap. This is their reunion." These acts of care, too often relegated to women in domestic spaces, have been taken to the streets, intervening in public life and transforming the environment of struggle through their presence. For protestors who have spent countless nights away from home in the fight for liberation, a home-cooked meal of *dolma* or the chance to have their clothes washed can bring monumental joy, comfort, and relief.

Me, We, Muhammad Ali

Packed in the plane were white, black, brown, red, and yellow people, blue eyes and blonde hair and my kinky red hair, all together, brothers! All honoring the same God Allah, all in turn giving equal honor to each other.

—Malcolm X, *The Autobiography of Malcom X*[15]

Outside the scope of the traditional art world, and not simply in reaction to moments of political crisis, I am interested in how decolonization and transcultural solidarity can happen in spaces we would never expect. The careful curation of Muhammad Ali's memorial service in Louisville, Kentucky transformed a space of grieving into a widely televised transcultural convening centered on care and empowerment.

A decade before his death on June 3, 2016, Muhammad Ali planned his funeral. The details of his funeral were thoughtfully designed and deliberately outlined by The Greatest himself, along with the guidance of his lawyer, spiritual advisor, and loved ones and recorded in a document so thoroughly it was dubbed "The Book." Muhammad Ali's death marked a major cultural moment that was felt across the world, empowering millions of fans, admirers, and viewers through his loss. The cultural moment was not limited to the passing of a legendary boxer but extended to the careful selection of individuals who spoke at his memorial service. The speakers echoed Ali's lifelong message of inclusiveness, love, coexistence, religious, political, and social consciousness, cross-cultural understanding, and the intersections of different struggles, in the United States and worldwide.

I argue that the curation of Muhammad Ali's funeral was a politicized act of creating an unconventional space of justice and positive change in the struggle for rights and freedoms. I came of age in a post-September 11 media environment, and to hear verses from the Holy Qur'an recited in Arabic

15. Malcolm X and Alex Haley, *The Autobiography of Malcolm X* (New York: Ballantine Books, 1999), 330.

with English translations, across mainstream TV networks, was a groundbreaking experience. At a time of rampant Islamophobia, the presence of Imam Zaid Shakir performing the Janazah (Muslim funeral prayer and ritual) on national TV was a hugely empowering experience for many Muslims in North America. In a stadium seating 22,000 people, including numerous dignitaries and heads of state, the speakers had a unique opportunity to have their voices heard by an audience of influencers. Every decision of the event was well-thought-out, from the order of the speakers to the translators. The most inspiring message behind the funeral was that of uniting the different religions and communities across the world. Muslim, Christian, Jewish, Buddhist, and First Nations people shared the same stage with their expressions of mourning and admiration for Muhammad Ali and all that he stood for in his struggles for civil rights and freedom.

In this book, you will find Leila Abdelrazaq's artworks addressing transcultural solidarity: "Resist Together" and "Sheroes." Her work illustrates and narrates the complexities of the Palestinian experience as a first generation Palestinian-American, and explores issues related to diaspora, refugees, history, memory, and borders. Much of Abdelrazaq's artwork illustrates social justice movements, and often the proceeds of her projects go to fund various grassroots organizations related to the subjects she portrays. Notably, Abdelrazaq's debut graphic novel, *Baddawi* (2015), is based on her father's childhood in the Palestinian refugee camp of the same name and his journey to the United States, and was also displayed in the gallery inside the installation "Take Care of Your Shelf."

Abdelrazaq's "Resist Together" is a linocut print of a group of women of various cultural backgrounds holding up the Black Power fist, with the title of the piece printed below them. It was created as the campaign image for "Arabs for Black Power," a group initiated by artists, academics, mothers, fathers, students, refugees, and community organizers with ties to Arabic-speaking regions. In 2016, the group released a statement to "declare our unwavering solidarity with the Movement for

Black Lives."[16] The statement was translated to Arabic, French, and Spanish in order to reach Arabs in the diaspora as well as those living in the Arabic-speaking world. It is included in the appendix of this book.

One of the initiative's organizers, Suhad Khatib, also exhibited a work she had created as part of her self-care process, a black-and-white ink drawing of mature roots and the germination of a tiny leaf. The work draws from the complex identity struggles she faced as a Palestinian woman visiting her homeland for the first time and her role as an organizer and speaker in the Palestine Contingent at the Ferguson October mobilization. "Big" was part of a larger series marking Khatib's return to painting after an eight-year hiatus, spurred by a powerful intention to reflect and self-heal, initiating the ongoing projects, "Identity Study" and "Theology Study," among others.

Palestine solidarity and the representation of the struggle for Palestinian human rights are a significant narrative thread weaved through the artworks featured in this book. Ahmad Naser-Eldein's "Ana Mish Ana" is a diptych showing Palestinian filmmaker Mahasen in two photographs: the first is a close-up of her face concealed in the *kuffiyeh* (the iconic Palestinian scarf); and the other is her seated for a regal photograph holding her young son at home. The contrasting images aim at "decolonizing the representations of Palestinians and to underline the empowering uniqueness of every human, by enabling the viewer to see individuals underneath the stereotypical image of the freedom fighters." The underlying concepts of feminism, motherhood, and public/private space create a complexity of identity that echoes through the theoretical narrative I have underlined, particularly as a counternarrative for the Palestinian struggle. This notion is present in earlier reflections on Iraqi women during the revolution and on the grief of Black mothers. Ahmad's project, therefore, is not only decolonizing the representations of Palestinians, but also represents the inherent matriarchal power of Palestinian women in contrast to the destructive (and over-represented)

16. See the appendix for the full statement from #Arabs4BlackPower.

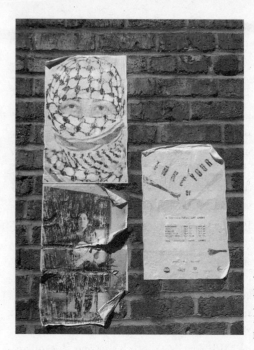

"Ana Mish Ana:
Mahasen" by
Ahmad Naser-Eldein
Photograph of street
poster, 2017

grip of patriarchy. The images were wheat-pasted in the streets of Montreal, adding another layer to the artwork by bringing a politicized domestic scene into the international public sphere. In addition to social, gendered, racialized, and class-determined categories of intersectionality, this work represents what Angela Davis describes as "interrelationships of ideas and processes that seem to be unrelated."[17] Drawing feminism into the narrative, Davis continues, "[i]nsisting on the connections between struggles and racism in the US and struggles against the Israeli repression of Palestinians, in this sense, is a feminist process."[18]

Minister of Culture: Emory Douglas

17. Angela Davis, *Freedom Is a Constant Struggle: Ferguson, Palestine, and the Foundations of a Movement* (Chicago, IL: Haymarket Books, 2016), 4.

18. Davis, *Freedom Is a Constant Struggle*, 4.

I said the P is for power, the A for action
The N-T because now is the time to get it done
See the H is for heart, and the E for effect
The R hold it down at the end for respect
Who am I? A panther
Who am I? A panther

—Yasiin Bey, "Can U C the Pride in the Panther"[19]

The illustrated image of a young Black boy holding up a newspaper that reads "All Power to the People," has been a central artwork in my life. I first came across it about a decade ago in a book about Emory Douglas, the former Minister of Culture for the Black Panther Party. Years later, a screenprint of "Paperboy Remix" was gifted to me by my dear friend and sister Susu Attar, and it became the anchoring artwork for the exhibit "Take Care of Your Self." It is one of the artworks that made me realize the role of art and the importance of artists in decolonizing and resistance movements, particularly with reference to Black liberation in the United States. During the exhibit, the screenprint was accompanied by an audio recording of an interview I had conducted with Douglas in December 2016 about his experiences as the former Minister of Culture for the Black Panther Party and his ongoing practice. Our conversation spanned his collaborations across cultures, the impact that art can have on sociopolitical issues, the intricacies of being a politically engaged artist in today's world, and collective empowerment through art. My questions to Douglas focused on how his lived experiences connected him to the SWANA region (South West Asia and North Africa). In doing so, I was hoping to bring forth the historical alliances between Arab, Indigenous, and Black struggles. Moreover, I was hoping to reference the collectivity of struggle, decolonization, and empowerment through art and transnational collaborations.

During our interview, Douglas recounted to me what was his foundational experience with transnational solidarity. It was his participation in the Pan-African Cultural Festival held

19. 2Pac ft. Yasiin Bey, "Can U C the Pride in the Panther," *The Rose that Grew from the Concrete*, Interscope Records, 2000.

in Algeria in 1969, during his time as the Minister of Culture for the Black Panther Party. While there, Douglas connected with artists and activists from all parts of the world, interacting and engaging with them through sharing art and ideas—often over dinners with the Palestinian Liberation Organization (PLO), Vietnamese and North Korean activists, and various African Liberation movements. During the festival, Douglas distributed copies of the Black Panther Community News Service newspaper and many artworks, posters, and materials. OSPAAAL (the Organization of Solidarity of the People of Asia, Africa and Latin America), which was founded in 1966 during the First Tricontinental Conference in Havana, Cuba, often remixed artworks by Douglas in their own production of poster art through their magazine, *Tricontinental*. Douglas mentioned how artworks from both OSPAAAL and the PLO were sources of mutual respect and inspiration for his own work with the Black Panther Party. These historic alliances across cultures, rooted in transcultural solidarity, still resonate strongly today amongst communities committed to decolonizing work and within resistance movements around the world.

Sam Durant, who compiled the extensive collection of artworks by Douglas in *Black Panther: The Revolutionary Art of Emory Douglas*, writes about the significance of his artwork, and how it "revealed the causes of oppression and most importantly encouraged the self-empowerment necessary to bring about change."[20] Emory Douglas' artwork is iconic of the struggle for self-determination, freedom, and resistance during the civil rights era in America. Moreover, his work is significant on a global level. His multiple encounters and collaborations across borders—from the Zapatistas in Mexico (documented in *Zapantera Negra: An Artistic Encounter Between Black Panthers and Zapatistas*) to the Maoris in New Zealand—have been monumental in forging alliances in solidarity across cultures, and in the development of international

20. Emory Douglas and Sam Durant, *Black Panther: The Revolutionary Art of Emory Douglas* (New York: Rizzoli International Publications, 2014), 20.

liberation art. In particular, the alliance between the Black Panther Party and diverse Arab struggles—from Palestine to Algeria—were of particular interest for me. From my position as an Arab artist who relates strongly with the Black struggle, my conversation with Douglas illustrates the connections between the different struggles, showing how interconnected and intersectional the relationships between the Arab and Black struggles have been.

Emory Douglas embodies the idea of how global anticolonial struggles and oppressed communities meet and inhabit shared spaces of empowerment through creativity. In the same way that bell hooks speaks about "language as a place of struggle," visual language and art from the margins are also "not without meaning, they are an action, a resistance."[21] The margin is the space where communities of struggle meet, as was illustrated through Douglas' travels to different countries to work with deeply rooted communities on projects that show the similarities and intricacies of sociopolitical issues from one community to the other. The margin thus becomes inclusive of many different communities struggling with similar issues. Despite cultural differences, the margin can grow so wide that it becomes a space unto itself, a "third space," where I believe Emory Douglas, and other artists who deal with issues of intersectionality across different struggles, inhabit. As Homi Bhabha describes it, "this third space displaces the histories that constitute it, and sets up new structures of authority, new political initiatives, which are inadequately understood through received wisdom."[22]

The connections between the Black Panther Party and struggles in Algeria and Palestine continue to this day, as Emory spoke to me about his recent trip to Palestine a few years back with a delegation of twenty union activists, former Black Panther political prisoners and other political prisoners, scholars and intellectuals. Emory Douglas' work continues to

21. bell hooks, "Choosing the Margin as a Space of Radical Openness," *Framework: The Journal of Cinema and Media* 36, no. 36 (1989): 15–23.

22. Jonathan Rutherford, "The Third Space: Interview with Homi Bhabha," in *Identity: Community, Culture, Difference*, ed. Jonathan Rutherford (London: Lawrence & Wishart, 1990), 207–211.

be relevant, as his travels continue to take him to communities where he shares and observes the everyday lives of diverse people struggling with similar issues that concerned him as the former Minister of Culture of the Black Panther Party over fifty years ago.

Transcultural solidarity / *TCOYS* poster

New Narratives

I have mentioned *counternarratives* throughout my discussion on decolonizing. It is a valuable term that I believe is important when it comes to understanding representation in the context of media and in cultural content about deeply rooted communities. I use *counternarrative* to describe an alternate representation, depiction, and/or definition to an existing harmful mainstream portrayal of a subject or people. I see it as a stereotype-breaking alternative to many of the destructive narratives that have worked to misrepresent, render invisible, vilify, oppress, or erase many of our diverse struggles and experiences as deeply rooted people. Yasmin Jiwani, a professor of Communication Studies at Concordia University in Montreal, describes them as subversions of dominant narratives, and considers them necessary tactical responses and interventions of resistance.[23] In the same way that the Black Panther Party created artwork and media in resistance to the systemic oppression of Black people in America, I view many of the works included in this book as offering necessary subversions.

The term counternarrative implies that there is another, more prevalent narrative that you are working to correct. It is in opposition, or resistance to, an "official" narrative. To always be working "in opposition to" is exhausting. For this reason, I would like to use the term *new narratives* to alleviate the burden of constant correction that is placed on the shoulders of many deeply rooted artists. I believe it also highlights the potential of a limitless imagination.[24] Cultural production is a powerful tool for articulating new narratives, and in a sense, for speaking truth to power, as debated as the term "truth" may be. In the section below, I offer a few curatorial and cultural projects that have presented new narratives to the mainstream. As we say at We Are The Medium, "power

23. Yasmin Jiwani, "Pedagogies of Hope: Counter Narratives and Anti-Disciplinary Tactics," *The Review of Education, Pedagogy, and Cultural Studies*, 33(4) (2011): 333–353.
24. With gratitude to Susu Attar for articulating the idea of limitless imagination through her practice and research.

in numbers, because numbers don't lie, the media does." The more projects that are engaged in creating counternarratives to the dominant, colonial, and hegemonic narrative, the more that dominant narrative loses its power and authority, and new narratives take precedence.

In the cultural milieu, subversiveness and counternarratives are powerful interventions that are rooted in critical thought and imagination. According to Jiwani, when these "tactical interventions" are performed—or experienced—in multiplicity, across generations, and from various locations along the margins, they can interrupt the "dominant colonial lens" and "decenter hegemonic thought."[25]

ICONIC: Black Panther

ICONIC: Black Panther, an exhibit curated by Susu Attar for the SEPIA Collective in Los Angeles in April 2017, was a curatorial project seeking to empower diverse communities through art. A critical aspect of the show was to make connections between past and present movements. In her statement on the show, Attar says the exhibit pays homage to the Black Panther Party while drawing references to contemporary movements such as Black Lives Matter and the protests at Standing Rock. Especially in the context of Trump's America, Attar reminds us how "today's issues of safety from police brutality, access to basic survival items such as food and clean water, and community building echo those that the BPP (Black Panther Party) tackled five decades ago."[26] *ICONIC*, as a new narrative to mainstream news representations of police brutality and structural injustices against people of color, came at a very significant time. It offered an opportunity for the Black community and other deeply rooted communities to reflect on a history of self-determination against all odds and to feel empowered.

25. Jiwani, "Pedagogies of Hope," 350.
26. Susu Attar, "*ICONIC Black Panther* Art Exhibition," *Medium*, April 11, 2017, https://medium.com/@susu.attar/iconic-black-panther-art-exhibition-ae11ace38943.

ICONIC: Black Panther
exhibition poster

The opening night of *ICONIC: Black Panther* was hugely attended, with over two thousand people representing the diversity of communities in Los Angeles convening for the purpose of the exhibit. I invited Susu Attar to be a part of *TCOYS* as both an artist and speaker, and initiated a public conversation with her as part of my own curatorial practice through our panel discussion "Counterparts in Conversation." In our conversation, Attar spoke in detail about the experience of curating *ICONIC: Black Panther* and its significance for a number of communities, including the art industry and the Black community in Los Angeles. Attar addressed the importance of creating alliances with other communities that inhabit shared spaces along the margins:

> these fully articulated art spaces tend to push us to the side, and the us in this sense was a combination of Black American artists but also people who identify with that struggle from other communities, and people who take from those lessons into their own communities and their own lives. . . . We, in our self-constructed communities, understand that but never see [it] reflected, because when you enter into a gallery or when you are approached by

more established art industry folks, it's like 'who are you, what is the category you fit into, how can we capitalize on that? OK, here's the corner we set up for you.'[27]

Attar engages with the idea that we, as artist-curators, have to take it upon ourselves to bring forth institutionally marginalized, transcultural narratives into existing art spaces. At the same time, there are often limitations in these settings such as industry timeframes. Because it often takes up to two years to program a show at an established gallery, it is difficult, if not impossible, to curate urgent cultural responses to current events. Similarly, the creation of temporary pop-up spaces presents its own set of problems, such as their limited visibility outside of the formal art world. A pop-up space may not receive coverage in major art publications or capture the attention of the contemporary art world's global community. The physical place of curation takes on added significance in care-full curation and its need to grapple with competing tensions: wide exposure for the issues, timeliness of the event, and an ability to reach target audiences.

In Visible Colours

Almost two decades prior, the film festival and symposium *In Visible Colours: Women of Colour and Third World Women International Film and Video Festival and Symposium* (*IVC*) held in Vancouver in 1989, created its own rupture in the dominant narrative of the experiences of women of color through filmmaking. The poster commissioned by the festival, a painting by Argentinian artist Nora Patrich, is included in this book. In the program of the festival, Jiwani describes how the festival is both an intervention and tactic for creating a counternarrative.

27. Interview by Yassin Alsalman with Susu Attar and Sundus Abdul Hadi, "Counterparts in Conversation: A panel discussion between Sundus Abdul Hadi and Susu Attar," July 14, 2017, *Take Care of Your Self* exhibition, Montreal, 7–14 July, 2017.

By showcasing the works of women of color and women from the Third World, we are reclaiming this pivotal notion of difference and redefining it to reflect our inner realities and concerns. We are expressing the unique nature and profound beauty of this difference. In so doing, we are actively celebrating and reaffirming realities and definitions of our own making which have survived until now, albeit in a sometimes muted and marginal fashion. Finally, the works featured in this festival pay tribute to the unceasing struggles and triumphant victories of women of color and Third World women who are at the frontlines of the battle against race, class and gender-based discrimination.[28]

Here Jiwani expresses the urgent vision of curating within struggle. The contributions of *ICONIC: Black Panther*, *In Visible Colours*, *Take Care of Your Self*, and other projects create a countercanon to the existing canon in the art and filmmaking worlds. It is a new canon championing the work and voices of people of color, by people of color. These projects also present opportunities for further dialogue on issues that affect our communities and provide temporary and safer spaces of transcultural convening. The multiplicity of these events, and the diversity of their intergenerational and transcultural curatorial visions, are a testament that the counternarrative strategies that have been developed over time have made an impact in the collective experience of marginality and culture. In this sense, the margin becomes a powerful space of care-full curation of art and media, empowerment in the context of struggle, rendering the margin a wide and limitless space in and of itself.

28. Yasmin Jiwani, "In Visible Colours: A Critical Perspective," *In Visible Colours: International Women's Film/Video Festival Brochure* (Vancouver, BC: Vancouver Women in Focus Society and National Film Board, 1989), 9.

THE LIVING ROOM:
IMAGES AND WORDS
BY THE ARTISTS

1 | Emory Douglas

Emory Douglas is the former Minister of Culture of the Black Panther Party. His artwork is iconic of the struggle for self-determination, freedom, and resistance during the Black Power and Civil Rights Movement in the United States, and played a significant role in the development of international liberation art.

What are your thoughts on how art can embody both collective and personal empowerment?

Putting the people in the art and making them the heroes in the artwork itself is personal empowerment. That is what took place in the context of the Black Panther Party. There were the illustrations that dealt with the social programs, like the free health clinics, free food giveaways, decent housing. . . . when the community saw that art, they were reminded maybe of their uncle, their father, or somebody that they knew. Therefore, that art becomes something that is making them the heroes, it's putting them on the stage. They begin to identify with it—and strongly. That is what happened with the art that was being done by myself and others who also contributed to the Black Panther Party. The broader empowerment was the art of solidarity. Afro-American solidarity with the oppressed people of the world. That was a part of the work as well.

2 | LEILA ABDELRAZAQ

"Resist Together" is part of a series of graphics and images created by Leila Abdelrazaq for the #Arabs4BlackPower group, which emerged in 2016 after the Movement for Black Lives (M4BL) released their policy platform. This platform explicitly expressed solidarity with Palestine. The group saw this as an important moment to do more intentional, proactive work in the Arab community to support the work of Black revolutionaries, acknowledging the fact that the Arab and Black struggles are inextricably linked. Only through Black liberation can we get free.

Abdelrazaq created the "Sheroes" illustration to support the campaign to #FreeRasmea. Rasmea Odeh is a Palestinian organizer who, at the age of seventy, was deported due to her activism in Chicago's Palestinian community. The illustration positions Odeh in the context of the struggle against colonialism and imperialism throughout history alongside other revolutionaries such as Yuri Kochiyama, Angela Davis, Assata Shakur, and Comandanta Ramona.

Can you share an anecdote or detail about the work exhibited and/or your process?

For me, the number one thing I'm thinking about when creating a piece is strategy. That might sound cold or unfeeling, but I'm constantly thinking about the function of every single aspect of what I'm creating—how it either intentionally reinforces or challenges assumptions, systems, etc. Every choice we make either reinforces or challenges certain power structures, and I want to be intentional about which ones I'm using and which ones I'm intentionally defying. I feel like art and comics are a way of manipulating people into caring about and engaging with political subjects that they otherwise would not want to think about.

3 | AHMAD NASER-ELDEIN

"Ana Mish Ana" is a photography project that sheds light on Palestinians' individualities by using the *kuffiyeh*, the iconic scarf, to conceal identity. The project aims at decolonizing the representations of "The Palestinians" and to underline the empowering uniqueness of every human, by enabling the viewer to see individuals underneath the stereotypical image of the freedom fighters.

What does self-care mean to you?

Far from capitalism and Western self-care, this concept has a very spiritual and positive connotation. Being a Palestinian, a

person of color, and coming out of a colonized society, it is projected in what makes me feel good about myself, and helps me get out of the traumas and advance in life.

On a personal level, part of self-care is not being apologetic about who I am, and about the different layers of my identity, culture, and political consciousness. It is all the work I do, aiming to develop self-love and confidence. Throughout my life, community has been a strong source of love, teaching me about and providing me with self-care. While practicing healthy boundaries, community taught me how to love myself and how to push my limits further. It was a source of well-being through the communion, love, the empowerment and the support we give to each other. I have learned that taking care of myself is taking care of my community by making sure we all advance and grow together. With community, self-care is projected on a large scale.

4 | MONIQUE BEDARD (AURA)

"Protect the children," from the series Akwelyá•ne | Kayá•tale (My Heart | Portraits) is a mixed media portrait of Sasha Lee Brown's niece and nephew at the forty-third annual anniversary of the occupation of Wounded Knee.

Through their art practice (sewing, beading, painting murals, journaling), Aura aims to use art as a form of transformation and intergenerational healing, mental wellness, identity, empowerment, and authenticity. They are inspired by stories, memory, community, and healing, individually and collectively. Aura aims to address intergenerational trauma in their own family with an emphasis on intergenerational healing to communicate experiences from the inside out. The core of their work is about living life from the heart and with a good mind. They also practice walking on the land with love and respect alongside all Nations and all relations, which is at the core of living in a good way. The art is their voice, their truth, and an extension of who they are. Aura's hope is that their art reaches others in a way that inspires thoughts and feelings, and ignites questions, curiosity, reflection, and self-love.

Can you share an anecdote or detail about the work exhibited and/or your process?

The process of gel transfers is really healing for me. The physical act of removing the paper pulp from the back of the photo really helps with my anxiety and fidgety hands. The transfers taught me to let go of "perfectionism" and allow the "imperfections" to show through as it's the beauty of the human experience.

5 | ROÏ SAADE

In Beirut, Dalieh is the city's last natural outcrop and shared space where the public can freely access the coastline for their own recreational purposes. Today, this last remaining informal space is on the edge of disappearing, as the land is being given over to big developers with plans for the construction of a private resort.

There's a wide range of nationalities and ethnic groups who share the space—most dominantly Kurdish, Palestinians, Syrians, and Lebanese. Dalieh represents resistance against the "growth machine" of real-estate tycoons and a reminder of our right to the sea.

What makes you feel empowered?

People who find the courage to go against the grain, challenge the status quo, and find creative ways to disobey and resist systems of domination empower me. I also believe that what empowers you is a combination of what you are and what you see in others. It is to say that what empowers you is also within you. To acknowledge this is to see your own significant potential beyond society's norms and to nurture your individual identity and experience. What interests me most are sensitivities and observations that create critical conversations.

Emory Douglass
"Paperboy Remix"
Screenprint
11" x 14.5", 2013

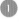

Leila Abdelrazaq
"Resist Together"
Linoleum block relief print
5" x 7", 2016

"Sheroes"
Ink on paper
11" x 17", 2014

Ahmad Naser Eldein 3
"Mahasen I + II"
Diptych from the series Ana Mish Ana
Photographs
12" x 18" each, 2017

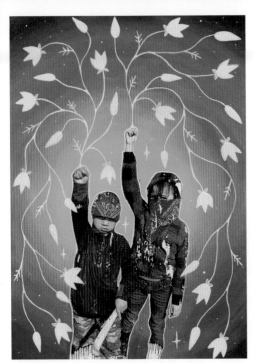

Monique Bedard (Aura)
"Protect the children,"
from the series Akwelyá•ne | Kayá•tale
[My Heart | Portraits]
Mixed media on watercolor paper
11" x 15", 2016

 Roï Saade
"Untitled" from the series The Epic of Dalieh
Photograph
22" x 14.5", 2015

Jessica Powless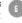
"Yótkų" / Digital Print
30" x 30", 2017

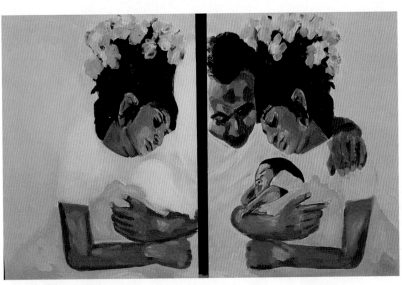

Susu Attar
"Sweet Dreams Pt 1 & 2"
Acrylic on matte board
24.5" x 16", 2017

8

Jihan Kikhia
"MAMA" and "BABA"
Digital Art
25" x 19", 2017

9 Sadaf Rassoul Cameron
"Beloved Queen Messenger I & II"
Two Photographs
11 x 17 each 2014-2016

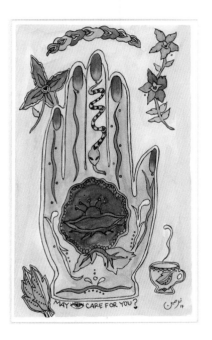

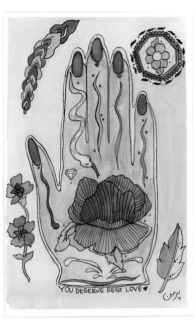

Narmeen Hashim ⑩
"May I Care For You?" and
"You Deserve Rest Love"
from the Hands That Heal series
Watercolor and ink on paper
5" x 7" each, 2017

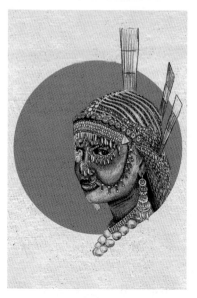
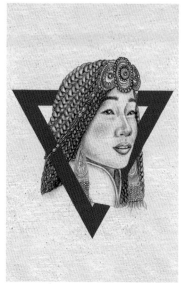

Niti Marcelle Mueth
"Proud Child of an Immigrant"
Drawing and illustration
20" x 30", 2016

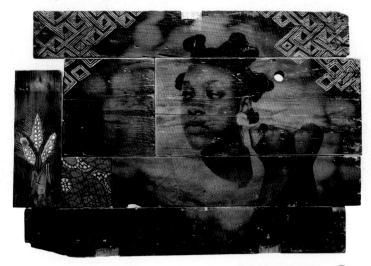

Shanna Strauss and Kevin Calixte
"Annick," from the Changemakers series
Photo transfer, acrylic, fabric, wood-burning,
woodcut on salvaged wood
22" x 33", 2016

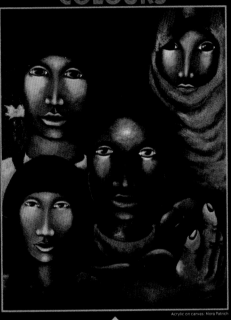

Acrylic on canvas: Nora Patrich

An International Women of Colour and Third World Women
Film/Video Festival and Symposium

November 15 – 19, 1989
Vancouver, Canada

Nora Patrich 13
Poster for *In Visible Colours*
International Film and Video Festival
Original painting printed on large
format poster paper
4' by 6', 1989

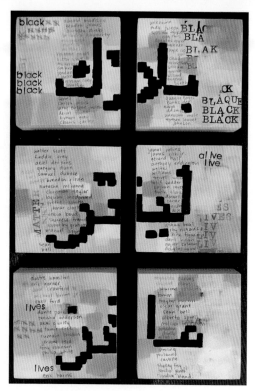

Samira Idroos
"Black Lives Matter"
from the Found in Transliteration series
Mixed media on 6 wood panels
4" x 4" each, 2017

Tara Jaffar
"Body Count," from the Body Count series
Acrylic ink, black tea, coffee granules, cigarette ash on paper
11" x 15", 2016

Julay "Sacred Spirit Ink" and Allos Abis
"Al-alam"
Live performance and installation
2017

Joseph Cuillier
"Genocide" from the Black
Abstracts Silk Series
Inkjet on silk
36" x 42", 2016

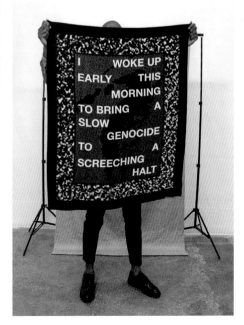

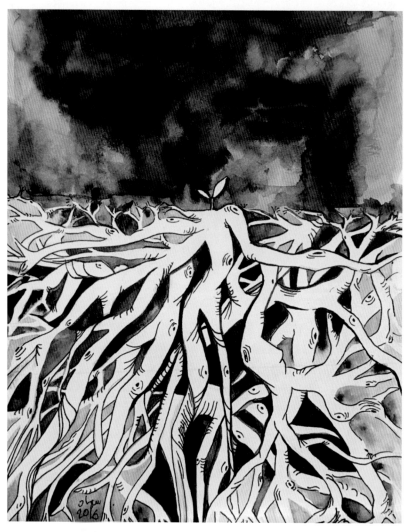

Suhad Khatib
"Big"
Ink on paper
9" x 12", 2016

Sundus Abdul Hadi
"Transformation" from the book *Shams*
Illustration and Screenprint
15" x 30", 2017

20

Dana El Masri
"*Shim El Yasmine*
(Smell the Jasmines)"
Installation / Materials: Jasmine
flowers, vine leaves, cotton,
Jasmine Grandiflorum Absolute,
silk, metal wire, 2017

6 | JESSICA POWLESS

My name is Jessica Powless, and I am Wolf Clan from the Oneida Nation of Wisconsin. In my art practice, I try my best to stimulate conversations that should be happening within our communities. These pieces promote self-love and also break down lateral oppression. My people are dynamic and creative; I hope that I capture the essence of my people to the best of my ability.

The meaning of the word *Yótkū* is "she has supernatural powers." I named this piece with the intention of celebrating the resilience and incredible strength of Indigenous women.

What makes you feel empowered?

Participating in my culture's ceremonies, speaking my language, and listening to my language are some of the main things that make me feel empowered. I come from an activist family, so anything I can do to help educate people on our culture and speak about our history as Indigenous people makes me feel empowered. Doing things that I never really wanted to do or think that I could do makes me feel empowered and reminds me that I can do anything.

7 | SUSU ATTAR

What makes you feel empowered?

I don't know how to name it. Maybe it's God.

8 | JIHAN KIKHIA

When I was six years old my father disappeared. His name was Mansur Rashid Kikhia and he was a Libyan human rights activist and peaceful opposition leader to Qaddafi's regime. My family was living in Paris when my father flew to Cairo for a human rights meeting and never returned. As a result, I grew up watching my mother, Baha Omary Kikhia, a Syrian American, search for him

for nineteen years as we moved between France and the United States. I have always been fascinated by my father's determination and my mother's perilous journey, as well as her ability to protect four children amidst the drama. While she suffered alone for over twenty years, she provided me with an abnormally normal life filled with joy, creativity, and self-expression. Art saved our lives.

Can you share an anecdote or detail about the work exhibited and/or your process?

The project gave me permission to grieve and in turn gave my family the permission to grieve with me. For the first time, the posters were manifesting my inner world, my relationship with my father and the trauma I struggled to share because of its complexity. It gave a focal point for us as a family to do some deep healing. Maybe this process that I went through was one of the moments of grief my family was waiting for because I am the youngest child . . . up until now I have resisted grieving and honoring my father. It freed me and my family to see me grieve. I evolved from one level of taking care of myself to a new level of self-care, grief, praise, and honor.

9 | SADAF RASSOUL CAMERON

My mother is an Afghan refugee who fled during the Russian invasion in 1978. She ended up in the desert of Santa Fe, New Mexico where she lived for over two decades. After suffering a series of great personal losses and following the events of 9/11, my mother "fled" the United States. Selling everything she owned and packing her life into a backpack, she spent three years traveling Central and South America by bus, seeking peace of mind from her PTSD and solace amidst the political tumult of the United States and its War on Terror. Eventually, she rooted herself in a small village in Brazil, a place that was seemingly devoid of antagonism towards the Muslim world and allowed freedom of expression for women. A culture that lives in celebration and joy, for my mother Brazil symbolized

the ultimate in self-care, a space to heal traumas and live with anonymity and dignity.

What are the intersections you find yourself in as part of your daily life and community? Through culture, identity, community, friendships, etc.?

Every moment is a clusterfuck of intersectionality. This morning I'm drinking coffee with my undocumented builder friends from Mexico. My Afghan mother just Skyped me from Brazil to tell me about the drought in her village that has skyrocketed the price of mangoes. I wish it were *iftar* so I could smoke with Fatima, but instead I'm jumping on a conference call about gender, justice, and money.

10 | NARMEEN HASHIM

In a world plagued by destructive forces, women use their hands for mending. Hands that paint protest signs and send letters to organize demonstrations of resistance. Hands that cook and apply the medicine, massage bruised bodies with touch. Hands that five times daily pray and beg and pray for peace. From the field to the frontline, the corner store to the kitchen, these same hands work tirelessly to accomplish the often invisible and still never-ending list of tasks to keep bodies sheltered, clothed, and comforted.

While the work of mending is of necessity, my practice acknowledges the need for self and community care amidst our collective duties. I reflect on what care feels like when turned inward, when turned to one another, and suggest at times the simple acknowledgement of the pace at which we move, the reminder for pause and rest can be the care or act of love in itself because for so many rest is an unaffordable luxury.

While the need for self-care spans across the spectrum of race, gender, color, and class, I believe for women of color, particularly low-income mothers of color, self-care can be considered radical as as the very societies in which we live so often deny the existence of mothers of color to the point that they suffer

from disproportionate rates of preventable disease and untimely death. My paintings contribute to the collective imagining of self-care as a beautiful act of resistance, particularly when performed by those who society has made most marginalized.

What makes you feel empowered?

My faith—Islam. My hands—strong. My tongue—fearless. My mother—boundless loyal love. My feet—free. *Alhamdulilah. Mashallah. Allahuakbar.*

11 | NITI MARCELLE MUETH

Thanks to all the immigrant parents out there who birthed us, loved us, supported us and raised us to each to be a proud child of an immigrant.

—Ailsa Fineron

What does self-care mean to you?

Be aware that your body and mind are connected and each needs to be treated differently and carefully to maintain a certain balance. Be aware that they are the center of our world and if they are well maintained then our world will be at peace.

12 | SHANNA STRAUSS AND KEVIN CALIXTE

Changemakers is an ongoing mixed-media project created by Shanna Strauss and Kevin Calixte that features Black women in Montreal who contribute to positive change in their communities.

As a Black girl, I'm used to my mere existence being a revolutionary act; but in preparation for the arrival of my son, I had to actively engage in the revolutionary acts of loving and trusting myself—because the politics that surround my skin, gender, and civil status would have made me believe that we are not worthy of love and life.

—Annick MF

Can you share an anecdote or detail about the work exhibited and/or your process?

[Shanna Strauss] I find joy and fulfillment in working creatively and collaboratively with others. Aside from working with Kevin Calixte on the photographic portraits, I also invite the women represented in the work to be active participants in their own representation. Through conversations I have with them they share more about themselves—their work, history, cultural background, ancestry, etc. Then, with their approval, I add symbols to the artwork that represent an aspect of who they are based on what they shared with me. Through dialogue, we collaborate on the outcome of each piece.

13 | NORA PATRICH

The poster for the groundbreaking film festival and symposium *In Visible Colours: Women of Colour and Third World Women International Film and Video Festival and Symposium* in Vancouver, British Columbia in 1989, was a painting by Nora Patrich. Patrich had to endure the harsh realities of Argentina's infamous Dirty War, during which the junta tried to wipe out a whole generation of people because of their political beliefs. Fearing for her life after her husband Haracio Machi was assassinated by the government's security forces, Patrich fled Argentina in 1977 with her two-year-old son Nicolas and her daughter Laura, who was then barely two months old. Exiled, Patrich formed part of the wave of South Americans that would disperse across the globe in the seventies. Finally arriving in Vancouver in 1982, she became an important part of the city's feminist community and a prominent Latin American activist. Influenced by the Spartacus Movement, a critical art movement in Argentina, she continues her art practice, dividing her time between studios in Vancouver and Buenos Aires.

The festival's cofounder and codirector Zainub Verjee recalls the context—and the need—for such an initiative for women in 1989:

IVC [*In Visible Colours*] was made, not found; it was historically produced and was historically productive. . . . [I]t emerged amid contestations on nation building and the making of a global neoliberal order, as much as the sociopolitical upheavals of the late 1970s and '80s that foregrounded race, gender, and the politics of cultural difference. *IVC* was primarily about the contested history of the modernist aesthetic and modernism in the visual arts and the making of the contemporary condition—as a historical marker—for the decolonized world. It asked: Who was defining this marker?[1]

14 | SAMIRA IDROOS

The "Found in Transliteration" series was prompted by the idea to abstract and pixelate everyday vernacular. Can ideas and texts be abstracted to make one look deeper? How could subjects and phrases that many have become desensitized to be looked at closer? The words being transliterated were an attempt to have one slow down. Whether by an Arabic reader who is reading a transliteration of "Black Lives Matter" or a non-Arabic speaker trying to make sense of the transliteration. Is there a way to bring meaning back to ideas that have been used so frequently that they have merely become slogans? As someone who is a Muslim artist, oftentimes Arabic is assumed to be Islamic text in my work. It immediately takes on a holy connotation. May these words hold the weight of scripture.

What does self-care mean to you?

Self-care is the most important thing I can do. It's prioritizing myself. Sometimes it comes in the form of physical activities or rituals to relax or calm myself. But I've realized that it's more of an everyday habit that has to form. It's learning how to care for yourself first, in all aspects of life. By setting boundaries with people. Making decisions. Prioritizing commitments. Finding ways to prioritize myself so I can do my best in situations.

1. For more on *InVisible Colours*, see: Rosemary Heather in conversation with Zainub Verjee et al., "In Visible Colours," *Canadian Art*, September 25, 2017, https://canadianart.ca/interviews/in-visible-colours/.

15 | TARA JAFFAR

As an outreach worker with Iraq Body Count (iraqbodycount. org), in 2015, I interviewed Iraqi individuals who had lost loved ones in Iraq (from 2003 to 2015). Born in Baghdad, of Iraqi origins, the impact was deep. At home, unable to cry or verbally articulate the depth of sadness and anger I felt, I turned to drawing as a self-support. This way, I released intense emotions I was sitting with, and later, integrated them as part of my Self.

I drew figures. Bodies. Some counted and recorded. Some forgotten. A number. Some alive, some aren't. Whole and visible, surrounded by loved ones. Some fading and forgotten. My mind stilled as I painted. As a wet layer dried on one sheet, I added some diluted tea and ink on another, and so on. The continuity was comforting, and the never-ending layers of war and destruction seemed to mirror the relentless cycle of violence in my beloved Iraq.

What makes you feel empowered?

My creativity. When I am in the moment creating—whether writing, devising movement pieces, or making images on paper.

16 | JULAY "SACRED SPIRIT INK" AND ALLOS ABIS

Al-alam is the Bontoc word for fern. It is a symbol for healers but also for healing and survival.

Al-alam is an installation and live performance of a hand-poke tattoo ceremony done by Julay (aka Sacred Spirit Ink) to mark Allos' healing journey as a trans Filipinx in a space where POC masculinity is invisible and unhealthy white masculinity is perpetuated. This installation serves as an intentional public display of one of the material attempts of decolonization work as a diasporic race. We are at the threshold of interrogating our own work as it occupies the violent contradiction that we are colonial subjects of US imperialism but also settlers of this land. In our political and artistic practices, we ask how we can heal and survive responsibly and in a truly liberatory manner.

What does self-care mean to you?

Julay: Self-care to me is honoring my truth and my boundaries: mind, body, and spirit.

Can you share an anecdote or detail about the work exhibited and/or your process?

Allos: My tattoos are timeless stories carved onto my flesh. Medically transitioning is limited to Western paradigms and colonial frameworks of masculinity don't fit quite right, but tattoos make body modification cultural, making space for transitioning to becoming decolonial. Julay and I started the chest pieces in 2015, a few weeks after I was arrested at a so-called "free speech" white supremacist rally. When taken into custody by the police, I refused to give my name so I was given the name "John Doe." Then "John Jane Doe" after an illegal strip search. Agency over bodily pain can be powerful and cathartic. As I move through the world as a young man of color, I grieve for the power and respect I gain through patriarchy, and the vulnerability and intense antagonism from white settler society. Choosing masculinity is choosing to negotiate realities that may seem contradictory, but in times of revolution, are hopefully complementary.

17 | JOSEPH CUILLIER

Black Abstracts is an ongoing public installation series that explores Blackness as a place, space, subject, and material in order to discover a new language of resistance to the politics of domination in American society. . . . Prints featuring socially engaged poetics via overlaying digital approximations abstracted from historical photographs of the Black experience are wheatpasted in Black communities. The silk prints exhibited in *TCOYS* are from the same series.

Can you share an anecdote or detail about the work exhibited and/or your process?

The project started because I was spending all this time writing my thesis and I knew no one I wrote it for would ever read it. So, inspired by the Situationists and the text-based graffiti of various protest movements, I started wheatpasting text from my thesis on walls around NYC. Over time, I added new elements and ideas to the project, but originally it was just a way to get my thesis writing out of the academic space where I knew it would be ignored and into the public.

18 | SUHAD KHATIB

Hi, my name is Suhad Khatib. I was born in Oman, grew up in Amman, lived in St. Louis for ten years, and am currently living in the Bay Area. I'm a mother, visual artist, and community organizer.

I never felt entitled to visit Palestine and didn't know anyone who lived there until I went there on a delegation in 2013. After a grueling seven-hour interrogation at the border, and during my very first bus trip to Ramallah, all five Palestinian passengers looked at me funny when I said, "My parents are Palestinian, but I'm Jordanian." They forgave my ignorance and insisted on paying my bus ticket. When we parted ways, the eldest turned to me and said with the kindest voice, "Welcome home." Those two words sparked an overwhelming realization of my Palestinian-ness. I was a thirty-four-year-old woman who had never been home before, not until then anyway. Every day of the following years I have attempted to learn how to think of Palestine as a Palestinian, and not as an ally.

Knowledge expands the soul and diminishes unrealistic social fears. So, from all the knowledge I have acquired over the past five years of organizing for Palestine and the Palestine Contingent to Ferguson, I feel like I have fewer fears about putting my heart on paper, literally. I'd like my art to continue to expand on my understanding of self-love, femininity, and feminism.

Can you share an anecdote or detail about the work exhibited and/or your process?

This painting is special to me. It is my first in eight years and the first in my series of thirty-one paintings in thirty-one days from October 2016. It is for the women who keep my head above the ground.

19 | SUNDUS ABDUL HADI

"Her head weighed heavy, but everything she ever needed was already there. She put a strand of hair in her mouth, slowly sucking at the water absorbed in the shock. She felt better already. She looked down at her body and all she could see was broken glass everywhere. She looked up at the window and saw that it had broken too, and its pieces of glass were bigger and stronger than the ones she had lost. Shams pulled the broken glass towards her and started to piece herself together, from her neck down. Slowly, the water she drank made its way into this new makeshift vessel. It was enough for her roots to regenerate."

—Excerpt from *Shams*

What does self-care mean to you?

Self-care means not neglecting myself, and my physical needs like eating and sleeping, and my spiritual needs like praying and yoga. It means being in communication with myself at all times and maintaining a positive outlook. It also means not allowing myself to give too much, share too much, and saying no when I need to. I'm not very good at any of these things, unfortunately, but they are always there in the back of my mind, like tools. Learning to use these tools before you break is the ultimate in self-care.

20 | DANA EL MASRI

Jasmines are a metaphor for renewal and self-acceptance. They symbolize hope and freedom, as demonstrated in Tunisia's

Jasmine Revolution in 2011. Their powerful scent contains aromatherapeutic properties—ones that are healing, calming, and aphrodisiac. Jasmines contain 2.5 percent indol—an ingredient with an unpleasant odor found in fecal matter. Yet when highly diluted, indol has floral notes. Jasmines thus represent paradoxical juxtapositions in life: the unpleasant within the attractive, the pain within beauty, the darkness within light. As human beings, accepting the "darker" or "undesirable" aspects of ourselves is one of the most important steps to recovery and self-care.

As this exhibition runs, these flowers will wilt, showcasing the life/death cycle. Close your eyes and listen with your nose as they sing their passionate song before extinguishing themselves in a dramatic death.

Can you share an anecdote or detail about the work exhibited and/or your process?

I wanted to approach this in the simplest way possible. By only using real flowers and re-simulating an experience—it almost becomes like a social experiment, where every person's experience relies purely on their reaction to the piece. The piece is highly emotional and only works with and through emotion.

POETRY

SOUKAYNA
Ode to Myself

Dear child,
when was the last time you really looked at yourself?
When was the last time you noticed the sun kissing your
 beautiful brown skin, covering it in gold dust.
When was the last time you hugged your body
and its rolls
and its scars
and its stripes
and its curves,
the way your mother held you as a baby.
Holding you so close to her beating heart, that at that
 moment,
nothing felt more real and honest.
When was the last time, my child, you allowed yourself to be
 scared?
To be vulnerable.
The world isn't always wonderful,
it is scary and ugly and filled with pain and misery!
But you, my child, are beautiful and strong and soft and loving
 and you
are my world.
When everything seems to fall apart and hope lingers between
 every string of my soul, you my child, are all that I have left,
 and you are my world.
When hunger strikes and my body fights,
when the voices grow louder and my spirit gets weaker, you!
beautiful, beautiful child, you are my world.
And I am sorry.

I am sorry I let you down so many times.
I am sorry I hurt you, covered you in bruises, left you starving
 hungry for love but only feeding on pain.
I am sorry my child.
I am sorry I wasn't there when you needed me most.
But I promise!
I promise my child, that I will love you
and hold you
and cherish you the way you deserve to be cherished.
That I will walk through fire just to hold you.
That I will turn every single one of your tears into a diamond
 so you know just how precious you are.
Glass will shatter,
the world will tremble knowing that every morning you
 wake up more and more loving, and stronger,
and alive.
You, my child, are the most authentic and honest being that
 there is because
you, my child, are unique.
You carry your own struggles, your own words,
your values, your story and your hope.
You, my child, are one in 7.3 billion, and that is enough for you
 to matter!
You, my child, are loved.
You are loved beyond comprehension.
You, my child, are loved, like love was meant to exist for you.

Can you share an anecdote or detail about the work and/or your process?

"Ode to Myself" came out of a very traumatic and difficult year for me. It speaks of a time where I felt like my world was ending, that my life was slowly reaching its end. In the midst of all the darkness and destruction, this piece came to life as homage to myself. I still had faith somehow. After the piece was written, I was approached to perform it in a festival. It was overwhelming to think my piece would be shared, hopefully reach people who felt similarly, and *inshallah* give them hope as well. Unfortunately, after jumping through so many hoops to make this piece bigger and better, by creating visuals to support it, having a friend create a cover for me, etc., I was told five days before the festival that the curators no longer wanted me to perform. I was crushed, felt so small, and went through a depression. I haven't touched the piece since then. I had opportunities to perform it, to share it, to finally give it life, but none of it felt right. This piece is part of who I am, of who I was, and who I want to be. It needed the perfect public, the perfect purpose, the perfect feeling of community and love. When Sundus approached me to perform it at *Take Care of Your Self*, I knew this project of love, community, and self-care was the perfect setting in which I wanted to share a part of myself. *Al Hamdulilah*, the bigger picture is often worth it.

JESSICA POWLESS
Women Pt. 1

In this world Indigenous women are only looked at as exotic/
used for erotic dysfunction/
since the beginning of races mixing n meeting our women
 were enslaved by their hand for our skin; our hair; our eyes;
 our lips, noses, our power they did not know about/
stealing of our grandmothers wombs was only the beginning/
and the sterilization of their daughters was the continuance/
the continuance of genocide that had bred patriarchy of men
 who knew better/
now we battle domestic violence and ignoring of our women's
 wisdom/
today we are still sold to the highest bidders in the world/
still exotic objects used for erotic dysfunction/
our daughters are watching the moves of the world/
preparing themselves for the worlds opinion about them/
we are the womb that carried the existence of the western
 hemisphere/
we are the food they ate to survive/
we are the medicines used to heal/
we are the water they drank/
the moon they watched/
the earth they still stand on/
lets start acting as if we remember/
pick each other up instead of beating each other down with
 western philosophy/
too many of us killed/
too many of us missing/
too many of us unsolved/
lets wake up together.

TEEANNA MUNRO
Untitled

Someone once said, "that behind every conscious man is a
tired Black feminist."

This is a letter to my ride or die sisters,
An ode and a love poem,
A thank you note toward women who have lit themselves on fire
so that we might find our way,
Who sacrifice in the name of love and justice

Strong woman,
what is it that breaks you?
Forgive me, but let me start here
because I have seen too many women stoic but burden ridden.
I am confused. Are we not allowed to cry too?

To which she replied,
Young woman,
Strength is not in our ability to endure suffering in silence, but
rather our ability to
love and to fight and to love and to fight
and to love and to love and to love again in spite of it.

**Can you share an anecdote or detail about the work and/or
your process?**

A seer once said to me that when I'm in my zone I feel God's
pleasure. This resonated so deeply with me because it put into
words what I experience when I teach and perform. I do this
work out of joy, love, hope, and necessity.

Suheir Hammad
@yosuheirhammad

'somewhere b/w care & cure.

#bossa

10:39 AM - 14 Sep 2014

CHAPTER 4
CURATING CARE

Care-Full Curation

"It's time to reclaim our story,
bring our children back to the days of glory.
For her, for him, for us, for me and
you, from the source of our Niya."

—Yassin "Narcy" Alsalman, "Life Science"[1]

Curation is a method of selecting works of art for presentation. It can also be defined as the act of choosing and organizing. According to Paul O'Neill, it is "through the process of researching, selecting, planning, organizing, structuring, framing, and curating group exhibitions as an artist or curator, one begins to understand how the curatorial constructs ideas about art."[2] If "careful" implies being mindful of danger, then I mean to approach the word to embody being "full of care."

1. Yassin Alsalman, "Life Science," in *Text Messages* (Chicago: Haymarket Books, 2020), 110.
2. Paul O'Neill, *The Culture of Curating and the Curating of Culture(s)* (Cambridge, MA: MIT Press, 2016), 7.

Care-full curation is an approach where complex issues are invoked with a goal that a collective convening might lead to an empowering or transformative experience. This is particularly important when issues of personal or structural violence are explored. How can care-full curation incorporate narratives of social justice and cultural understanding? How can traumatic world events translate into cultural moments that spur dialogue and change?

What guides my method is an interest in the potential for curated spaces to transform into interventions of self-care: politicized acts of creating spaces and conversations of healing and justice in the continued struggle for rights and freedoms. I want to explore how, through care-full curation, the heavy subjects of trauma, loss, and displacement might transform into opportunities for healing and empowerment for both artist and audience.

My approach to care-full curation, in the context of *Take Care of Your Self*, references the care that went into the project through both the interactions with the artists involved, whose work is intimately tied to their individual and community struggles, as well as the care embedded in the creation of a safer space for these stories to exist. Due to the sensitive nature of the show, many of the artists involved had submitted work that was connected to their experiences of struggle, trauma, and systemic oppression. Creating a *safer space* of sharing between myself and the artists was an intentional element in my communication with the artists. The process of working with the artists was, in some cases, part of their healing. In Jihan Kikhia's case, her submission became a part of her grieving process, honoring the life of her father Mansur, who had gone missing nineteen years ago. Three of the artists had shared that they had almost "quit" making art before finding out that their submission was accepted as part of *TCOYS*. A number of artists had not yet claimed the title of "artist." Even though they are all creatively gifted, they had been knocked down by the indiscriminating imposter syndrome.

There were many "firsts" as a part of this project, myself included. This relates directly back to the institutions of art and the hierarchies they perpetuate of artists occupying different

"levels." The feeling of being supported helped revive a sense of purpose for some of the artists. The direct relationship of giving, receiving, and sharing with other artists can truly create a bond of genuine care between artist and curator. Friendships were made and strengthened during this process, between myself and the artists and between the artists as well.

In describing the method of care-full curation, I use the word *careful* as a reminder to be self-aware of the roles we play—as curators or otherwise—in perpetuating problematic systemic tropes. Maintaining the artist's authentic voice is extremely important. One of the ways to do that is by avoiding over-editing artists' statements to ensure that their original message remains intact. It is also being conscious of using the artists' cultural backgrounds as a labeling device that could potentially tokenize the artists and their work, playing into identity politics that can be more harmful than helpful. In curating *Take Care of Your Self*, I chose to avoid direct labels of nationhood and identity, and this was also in reference to the theoretical foundation of intersectionality that was implicit throughout the exhibition. I didn't feel it necessary to highlight the identity of the artist as a way to contextualize their work, unless the artist explicitly chose to. I let the artists' experiences and expression to do that work.

This approach is informed by my own experiences as an Iraqi artist creating work about the war in Iraq over the past decade, where my work was read in conjunction to my identity rather than about a collective experience.

Curating as Artist-Curator

My approach to curation is a creative exploration of the definition, purpose, process, and method of curation as an artist-curator. I used to think being involved in curatorial projects as both an artist and curator would create tension or conflict. Through my own practice and research, I have come to understand that the artist-curator— when a practicing artist uses their own work as part of a curated show—has a longer history that goes back to the 1990s or probably

much earlier, even if it wasn't explicitly named. Artist and writer Paul O'Neill tells us, "the emergence of the figure of the artist-curator can be seen as an attempt to move beyond the dominant roles within the normal divisions of the art world—a refusal that has contributed towards emergent forms of collective agency."[3]

The starting point for *Take Care of Your Self* was a selection of illustrations from my book *Shams*. In order to invoke a larger community beyond my reach, I shared a call for submissions to the public that asked artists from Arab, Black, Indigenous, Brown, Muslim, and marginalized communities to submit work engaged in the concepts of struggle and self-care. The call for submission was also translated into Arabic. By the deadline, I had received over sixty submissions from Baghdad to Brooklyn, from diverse artists in diaspora to Indigenous artists from various Nations. I was over-whelmed by the response, learning that my network was wider than I had initially conceived. I was completely inspired by the quality of the artwork submitted. A common thread was powerfully present: artists of various backgrounds from around the world have been engaging with the concepts of self-care and empowerment in the context of struggle on a deeply sophisticated level for years. After the submissions closed, I set upon the tasks of carefully selecting works to craft the exhibit's narrative and defining my own role as artist-curator. Moving past my own reflections on struggle and self-care, I was able to draw connections with other artists themat-ically and conceptually, taking the conversation on care to places I wouldn't have been able to access alone.

In selecting the works for the exhibit, my curatorial approach was rooted in how the works can be interpreted in the context of self-care, struggle, decolonizing, the creation of new narra-tives, and ultimately, their potential to heal and to empower. To be responsible for the works and voices of all participating art-ists was a privilege I did not take lightly. The most empowering result of the call for submissions was its role in connecting the artists to one another, creating a community of artists engaged with similar concepts of self-care and struggle.

3. O'Neill, *The Culture of Curating*, 110.

Intentionality

As an artist-curator, and also as a mother, I felt compelled to approach a curatorial project involving twenty-seven artists of color with care, but also to treat the space, audience, and all visitors with care. Perhaps this can be easily attributed to my disposition, but in fact, it is a conscious act and an intervention. My intention is to nurture a culture of care in the context of a community of artists and also within academia and the arts. This is the world I was straddling in the time leading up to *TCOYS*—art, motherhood and academia—and I was eager to find a balance between them all. This is the world I was straddling in the time leading up to *TCOYS*—art, motherhood and academia—and I was eager to find a balance between them all.

Throughout this period, I was reading spiritual texts which were deeply influencing my conceptual development and personal growth. Verses from The Holy Qu'ran, Buddhist teachings, and various books about self-care, spirituality, and healing have been my greatest allies in developing my own skills of articulation and intention-setting in my life, and ultimately, throughout this book. Coming from a family of artists, I never felt a need to separate my family life from my work, especially as I became a mother myself. There was family involvement at every stage of this project, from my parents, my partner, and my children.

I should elaborate. *Take Care of Your Self* was my research-creation project for my Master of Arts in Media Studies at Concordia University. I was pregnant with my second child, a daughter, who was born one year into my studies. By year two, I was juggling a toddler and a newborn while this project was also growing and expanding. I spent my days taking care of my children, and by night, I was engaging in more care work through curating. I loved it and wouldn't have done anything differently. Even today, I have maintained the same structure of mothering full-time while making time for my creative practice after the children sleep. I'm still not entirely sure if this is the right way; in fact, it is definitely the "hard" way, but I've spent my life observing my own mother do it the same way.

It involves a lot of sacrifices, but the rewards are plenty. I'm all too familiar with what stress can do to working environments, bodies and spirit, as I'm sure you are too. It's an everyday struggle to keep stress levels down. I have made a firm and conscious decision not to let stress interfere with my mothering and my creative work. Some days are better than others.

Ceremony

Artist talks circle at the gallery

Healing arises from collaborative conversations that exchange information that was not previously available, resulting in transformation. By information, I mean what story carries that is impossibly more complex than our usual declarative knowledge structures. When a new flow of information passes from one to the other through dialogue, it changes people.

Dr. Lewis Mehl-Madrona, *Healing the Mind Through the Power of Story*[4]

4. Lewis Mehl-Madrona, *Healing the Mind Through the Power of Story: The Promise of Narrative Psychiatry* (Rochester, VT: Bear & Company, 2010), 230–231.

The power of ceremony and storytelling as medicine to heal has been addressed in depth by Dr. Lewis Mehl-Madrona in his book *Healing the Mind Through the Power of Story: The Promise of Narrative Psychiatry*. In the book, he blends his experience as a Western-educated physician and his experience and knowledge in the field with traditional Indigenous wisdom and story. The book serves as a tool and reminder that "through the appreciation of the power of story, we can build bridges between the Indigenous and the modern worlds to create an integration that allows for more people to be healed."[5]

It is important to remember, for many years Indigenous ceremonies were prohibited by both the Canadian and US governments, and sites of ceremony often became sites of massacre, as with the Massacre at Wounded Knee in 1890.[6] Through government policy, cultural genocide took place over centuries, in addition to actual genocide through which the population of Indigenous people significantly diminished. The forceful and violent prohibition of Indigenous dance, language and ceremony speaks to the power of ceremonial convening. The effects of the cultural genocide of the First Nations people of Turtle Island has heightened the importance of Indigenous resistance to colonial narratives by focusing on cultural empowerment, ceremony and language. The significance of Wounded Knee as a site of resistance for the Sioux Nation and other First Nations of Turtle Island is referenced in Monique Bedard (Aura)'s work "Protect the Children," a collaged portrait of "Sasha Lee Brown's niece and nephew at the 43rd annual anniversary of the occupation of Wounded Knee" (see Plate 4). The image shows two young siblings holding up the Black power fist, their faces covered with bandanas, in a beautiful show of shared struggle and empowerment in the anticolonial resistance movement.

During the artist talks for *Take Care of Your Self*, Jessica Powless chose to introduce herself in her Native Oneida language. Afterwards, she chose to speak to us about the impact of ceremony on her life and community. This was an act of resistance, and

5. Mehl-Madrona, *Healing the Mind Through the Power of Story*, 10.
6. Mehl-Madrona, *Healing the Mind Through the Power of Story*, 11.

brought with it the awareness of a loaded history from which we could pursue connections, seek further knowledge, and persist together. Powless' offering to bring language and ceremony into the space during the artist talks decolonized the space and affirmed how much work she has done to preserve her language and traditions. After a fifteen-hour drive from the Oneida Nation of Wisconsin to Tiohtià:ke (Montreal), Powless courageously and generously shared her gift with us.

Partitioned away from public view, yet still accessible for three visitors at a time during the opening night of *TCOYS*, was the installation and live performance of a hand-poke tattoo ceremony, "Al-alam," by Julay (Sacred Spirit Ink) and Allos Abis. The sacred space of ceremony created by Julay and Allos was to mark Allos' healing journey as a trans Filipinx, making visible POC trans masculinity, an identity subjected to violence and invisibility in our colonial, patriarchal societies. They started the ceremony by performing opening rituals, such as setting intentions and honoring the land and the ancestors, before engaging in a three-hour tattoo healing session, with Julay as the vessel to provide the healing ceremony for Allos.

In addition to the ceremonial opening of "Al-alam," all *TCOYS* events began by reading the territorial acknowledgement, honoring the land, and setting intention. This is the text we recited:

> We would like to begin by acknowledging that this event is taking place on unceded Indigenous lands. The Kanien'kehá:ka Nation is recognized as the custodians of the lands and waters on which we gather today. Tiohtià:ke/Montreal is historically known as a gathering place for many First Nations. Today, it is home to a diverse population of Indigenous and other peoples. We respect the continued connections with the past, present, and future in our ongoing relationships with Indigenous and other peoples within the Montreal community."[7]

7. This territorial acknowledgement was created by Concordia University's Indigenous Directions Leadership Group in 2017. The entire territorial acknowledgement, and more about why it was written this way, is available at https://www.concordia.ca/about/indigenous/territorial-acknowledgement.html.

One of the events during the week-long exhibit was "Tea Afar: Syria," by Los Angeles-based artist April Banks. The *Tea Afar* or *Chai Chats* series, which is often undocumented, "is an intimate gathering of invited guests, one tea master, small bites, three storytellers, travel photography, and regional music—about one country, taking place in one evening." In the context of the ongoing Syrian crisis and the exodus of refugees fleeing the conflict, "Tea Afar: Syria" created a necessary space to share stories, heal, and spread awareness. The ritual of gathering around tea, the care put into every little aspect of the evening by April and our small community of artists who offered help, and the undocumented storytelling session truly felt ceremonial. In response to my questions about how *Tea Afar* came to be, Banks offered:

> I've been asked why tea? I've heard it said that tea is more about the ritual than about drinking. For me the thirst is twofold: a desire for the taste and for the ritual. Tea is the medium, the catalyst for gathering. It brings people together to pause for a moment, to tell stories of the day, to shift modes from hectic to relaxed. It fosters connection and communion. Whether at home or as a stranger, the ritual of tea can create safe space, across language barriers, politics or war. And it just so happens that much of the world drinks tea. There is much to be learned from a single leaf that is brewed in as many variations as the people who touch them.

Tea had a lot to do with *Take Care of Your Self*, actually. Beyond April's contribution with "Tea Afar: Syria," I always had a fresh pot of Iraqi black tea with cardamom ready. I would offer every visitor a cup. This is part of my tradition; whenever anyone visits my home, I make them a cup of tea. I extended the same ritual to the gallery space. This is customary in many cultures around the world. The offering of tea makes people feel at ease and welcomed, and is often a buffer, an ice breaker, an offering, or simply an act of care.

Mehl-Madrona's emphasis on community, ceremony, and storytelling as key ingredients in both cultural and personal

well-being—and also, in my opinion, empowerment—is instrumental to my approach of care-full curation, particularly in the context of an exhibit about care and struggle. Incorporating performances and rituals during the vernissage, in addition to the artist talks, workshop, and panel discussion, created a more caring space. In the context of an art exhibition, I question how ceremony, the spiritual, and ritual can be meaningfully integrated into art spaces without culturally appropriating or imposing specific religious rites on the audience. Approaching the act of convening as ceremony gives a deeper value to the gathering, and allows for the creation of a collective experience. Convening is an act of curation as well, bringing people together in order to reflect, participate, and engage in dialogue that could be potentially transformative and enlightening. In the context of an exhibition, stories are embedded within the artworks exhibited, the conversations had in their presence, and the people who you bring together to engage in the space. However, the space must be safe enough to allow for these elements to be explored in their full potential. I will cover this in detail in Chapter 5, "Space."

In *Conversation Pieces*, Grant H. Kester studies the work of numerous artists and collectives that have created works of dialogic art. He argues that art that takes the form of conversation reframes dialogue and helps artists and the respective communities challenge fixed identities, categories, and discourses.[8] Building on the notion of dialogic art, there is great potential in consciously exploring the medium of conversation through the specific practice of curation. In my own practice as a curator, I approach the dialogic elements of an exhibition with Kester's framework in mind, treating panel discussions and artist talks as conversational art pieces in their own right. The medium of storytelling therefore takes center stage, a tradition shared by many diverse communities. Storytelling, as a form of oral history, is an extremely powerful tool in reclaiming our histories and honoring our roots. It has been used in both public and private life as a healing tool for many communities whose histories have

8. Grant Kester, *Conversation Pieces: Community and Communication in Modern Art* (Berkeley: University of California Press, 2013), 8.

often been misrepresented and erased by systemic oppression or displacement. In the months following my daughter's birth, a secret well of stories opened up in my mother and aunt. Guided by an unspoken desire to continue the wisdom embedded in the stories of our ancestors, they shared dozens of stories about my maternal family history and our roots. Their acts of storytelling were not ceremonial, they were conversational, and they were private. Not all storytelling must happen in the public sphere to be effective as alternative knowledge transmission. We can choose to carry them into the public sphere or not.

The Stories in Between

Storefront gallery view, *TCOYS*

Communities can create powerful shared narratives, which allow all of their members to look in the same direction, to share intentionality, and to experience the belongingness of coherence with other people.

—Dr. Lewis Mehl-Madrona[9]

9. Lewis Mehl-Madrona, *Healing the Mind Through the Power of Story*, 255.

Cuillier's posters outside the YMCA, Montreal

Weaving a narrative into a physical space is one of the most important creative undertakings for a curator. My approach is to create a cohesive narrative around the works rather than through them. The metaphorical space between the works impacts how the viewer experiences an exhibit, as many of the artworks are in conversation with one another. The order of the works in the walk-through of a space should take the viewer on a journey into the diverse stories embedded in the works, regardless of where the viewer begins. In the following paragraphs, I describe the walk-through of the exhibit *Take Care of Your Self* and illustrate how I translated the theoretical framework of my research-creation into the selection of works and their installation.

Building the exhibit around three works created a tree-like curatorial process, with Emory Douglas' work serving as the roots, Leila Abdelrazaq and my work representing the trunk, and the rest of the works are the branches. It is the sum of the parts that make the whole great. However, as the curatorial process developed, each artwork selected proved to be a standalone

Left side of the gallery

and impactful piece, capable of inspiring reflection in the viewer in the context of struggle and self-care.

Renting a storefront gallery space in a busy commercial neighborhood, I wanted the exhibit's conceptual ideas to reach passersby, whether the gallery was open or after hours, and whether they chose to enter the space or not. The public nature of the gallery meant that my audience would be as diverse as the city we live in and could potentially attract all kinds of visitors. The window displays were central to the exhibit. First, they take the art directly to public space by having the artwork face outwards, and second, they make an intervention into the daily movements of the passersby by presenting them with text-based art to literally stop and read. The works served as markers for a safer space, inviting into the gallery space those passersby with similar experiences or individuals who express solidarity with the messages in the works. At best, the public window displays serve to pique the public's curiosity enough to come inside and take a look around before returning to their daily movements.

Joseph Cuillier's silk posters from the *Black Abstracts* series were suspended in each window display. One read: "Empires

Right side of gallery

crumble like papier maché pillars wet by rain because they are irrational"; and the other, "I woke up early this morning to bring a slow genocide to a screeching halt." Both posters, plus one more from the same series, were printed on paper in bulk and stacked inside the window display, inviting visitors who entered the gallery to take one home for free. The same paper posters were also wheatpasted around the city to continue Cuillier's project of taking this work to Black neighborhoods in different cities in the United States and elsewhere. We postered the prints on the outside walls of the YMCA residence in Montreal, where many refugees spend their first days in Montreal, with many migrants hailing from Haiti, Syria, and Afghanistan. It is also where many Indigenous and Inuit people stay when visiting Montreal for medical treatment. Several years later, the posters are still up.

The left side of the gallery started with visual works that spoke about personal loss, trauma, and healing, featuring works by Jihan Kikhia, Susu Attar, myself, and Tara Jaffar. We are all Arab women. Located right in the middle of the left wall was Emory Douglas' screenprint "Paperboy Remix" with an accompanying audio piece of my interview with Douglas, acting as a

centerpiece that split the wall into two narratives. Following Douglas' piece were works that spoke of empowerment, resilience and community, featuring artworks by Jessica Powless, Shanna Strauss with Kevin Calixte, and Samira Idroos. Further down the wall were works that spoke directly to the experiences of women of color and self-care, illustrated by Narmeen Hashim and Sadaf Rassoul Cameron's works. Nestled inside a cubicle at the far end of the gallery was the installation "*Shim El Yasmine* (Smell the Jasmines)" by perfumer Dana El Masri, a healing space featuring live jasmine plants and scent. Behind the cubicle, partitioned off from the main gallery space, was the tattoo performance and installation "Al Alam" by Julay of Sacred Spirit Ink and Allos Abis.

Leila Abdelrazaq's print "Resist Together" was followed by Monique Bedard (Aura)'s work "Protect the Children." Both works feature the Black Power fist and resistance against white supremacy.

Beside them was Lebanese photographer Roï Saade's "Untitled," a silhouette of two young divers in Dalieh, from a series about the coastal community's resistance to real-estate tycoons and the universal right of access to the sea. The wall ends with Ahmad Naser-Eldein's diptych "Mahasen I + II" from the "Ana Mish Ana" series, about the representation of Palestinian resistance and identity. The second part of the right-side wall continued with works that referenced images of empowerment, women, and diverse communities. This wall housed the *In Visible Colours* poster, and artworks by Leila Abdelrazaq, Suhad Khatib, and Niti Marcelle Mueth.

Included in the exhibition was the installation "Take Care of Your Shelf," a bookshelf with a collection of books visitors were welcome to leaf through. The glass display case housed books and literature that informed the theoretical and conceptual framework for *TCOYS*. It also displayed works by authors dealing with similar issues of struggle and self-care.[10] Also on view was the program from the *In Visible Colours* film festival from 1989.

10. The case included many of the references I used as part of the research for this book.

Shim El Yasmine [Smell the Jasmine]

Dana El Masri's installation "*Shim El Yasmine* (Smell the Jasmine)" created a space of its own in the exhibit, which brought visitors coming specifically to *TCOYS* to experience it. In this site-specific installation, El Masri, a perfumer and interdisciplinary artist, used scent as her primary medium, motivated by the healing power of jasmine and the flower's symbolism of renewal and self-acceptance.

In a cabin-sized enclosure in the gallery, she suspended jasmine vines from fencing above, with three different jasmine plants at the foot of the cabin, and on the walls were delicately sewn silk tufts infused with jasmine absolute oil. The opening of the space was then curtained with a light white mesh drapery, creating a jasmine sanctuary of sorts. Visitors were welcome to enter the space and spend time there. Of the work, Dana writes:

> The power of scent is incomparable, as it is the strongest sense linked to memory. I chose to create this piece to showcase my inner struggle with light vs. dark. As someone who has lived with anxiety and depression for most of my adult life, I felt that only jasmines could represent the dichotomy of beauty and pain. This was a chance to express my vulnerability while also helping others accept theirs as well. By accepting the darker aspects of ourselves, we come to appreciate ourselves and others in the process.

During the "Taking Care of Us" workshop (detailed in the next section), one of the exercises included choosing one artwork to connect to and reflect on. I chose to enter El Masri's jasmine sanctuary. I spent fifteen minutes in the space, experiencing it in a completely different way than I had in the days leading up to the workshop. Although I had seen El Masri working tirelessly sewing, hanging, draping and installing, the energy of care and love that went into this artwork was still present in that small enclosure housing it. The scent of jasmines tapped into a raw and powerful emotion within me that I had

suppressed for a long time: nostalgia. This emotion had me reflecting on the scents of my childhood, of my displacement from my homeland, on the child within me, the beautiful contrasts of motherhood. Partly due to the tension and exhaustion I was under after long weeks of intense work, finally having a moment to myself, I was able to cry it out and stick my nose as close as possible to those little tufts of jasmine for the emotion to resurge, safely and ritually. I was open to receive the lessons and truly be present in that space.

One of the most symbolic aspects of El Masri's installation was that it required daily care. Every day, Dana would come to the gallery, water her jasmines, tend to them, and literally take care of them. After the exhibit ended, we each took home a plant, and the cycle of care continued.

Poetry

Facing the street in the gallery window display was a poem by Jessica Powless, titled "Women Pt. 1" (see page 103). The poem is about the historical and ongoing crisis of missing and murdered Indigenous women. I felt it was imperative to present this work to a public readership by bringing the narrative of the missing and murdered Indigenous women to the street, in the words of a woman from that community. This is a direct counternarrative to what we often experience—non-Indigenous people making statements about the missing and murdered Indigenous women crisis, often divorced from the circumstances of colonialism, residential schools, and other traumas faced by First Peoples in Canada and the United States, or completely disregarding it by not talking about it. Powless writes about her work:

> As Indigenous people we have multiple layers of memories and thoughts that intertwine with today's Western influence on society. I try to stimulate thoughts that come from our identities as Indigenous people, to inspire people to think outside of their comfort zones, to attempt to get

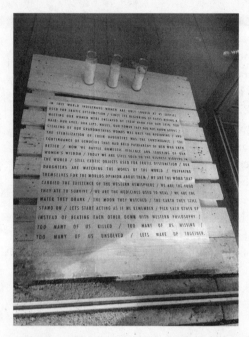

Window view of
Jessica Powless' poem
"Women Pt. 1"

Soukayna's
"Ode to Myself,"
street view

TAKE CARE OF YOUR SELF

others to see life through the people who have survived tragedy both historic and present.[11]

Powless' "Yótkū," an illustration of an Indigenous woman as a superhero (see Plate 6), was exhibited inside the gallery. The other work of poetry on exhibit was by Moroccan artist and writer Soukayna, "Ode to Myself" (see page 100). The poem was also performed during the vernissage in a "flash" performance: no microphone, no stage, just the poet and their voice projecting to a full gallery.

The poem is about self-love, self-acceptance, and brought many visitors to tears. Their mother, who was standing by them during the performance, was in tears throughout. It was Soukayna's first time performing it in front of an audience. In it, they write from the perspective of a mother to a child, or from an adult speaking to their childhood self. This was a life-altering and healing experience that led them to publish their poetry book, *Words*, a year later.

After the exhibit closed, I took the vinyl sticker on which the poem was printed and pasted it onto a lamppost in my neighborhood. The poem lived on for two years on a street corner in Montreal until it was partially ripped off.

"Taking Care of Us": The Workshop

On the fifth day of *TCOYS*, the workshop "Taking Care of Us" took place in the gallery. The facilitators of the workshop were writer and producer Jess Glavina; storyteller, poet, and educator Teeanna Munro; and mother, academic, and creative maker Annick MF. The three facilitators created an intimate atmosphere of communal introspection on self-care via movement and gesture, free writing, and discussion. Reflecting on how the three women conceptualized the workshop, Glavina wrote to me:

11. Statement by Jessica Powless from the project description submitted for *TCOYS*.

When my sisters Teeanna and Annick and I created this workshop for *Take Care of Your Self*, we continued to revolve around the idea of "Taking Care of Us," understanding self-care as intrinsically located within community care where our well-being and ability to care for ourselves is inextricably tied to our relational context: the people around us. Our capacity to heal and make moves—even when impelled by the self—is also given space and witnessed by others.

During the workshop, excerpts of poetry and monologues were performed by the facilitators, in conversation with the "Changemakers" painting by Shanna Strauss and Kevin Calixte on view in the gallery. "Changemakers" is an ongoing mixed-media series that features Black women in Montreal who contribute to positive change in their communities, and the artwork exhibited at *TCOYS* is a portrait of Annick MF. Annick read from a powerful monologue performed during the workshop, expanding on the intersections of race and self-determination in her own journey of mothering her child. Here is an excerpt of Annick's monologue, "He's Here":

> How daring of me, especially as a young Black woman, to feel that I am whole on my own; to feel in control of when and how things happen to my womb; to feel empowered and intentional in planning for my child. What was once one of the most intimate choices a person can make for their life and body has become one of the most public, regulated, politicized, and policed undertakings in this society—especially for marginalized bodies. Here I am just a few weeks postpartum and I am overjoyed to have taken on the revolutionary act of mothering my little Black boy. It means so much for our past, present, and future.

Annick read this piece with her eight-week-old son wrapped up against her chest. In the room was Annick's mother, who was there as a participant and support system for her daughter and grandson. The spirit of family and ancestry present in the gallery transcended time.

In Glavina's words, "this cofacilitated session honored undervalued labor in community and the small acts of love, work, and memory that make revolution." The workshop created a very moving, intimate rupture in our daily lives where the participants were all equally impacted by the works in the exhibition and the environment we created together of reflection, safety, and healing. All eleven of the participants were women.

Through the energy of women, old and young, mothers and not, friends and strangers, *TCOYS* transformed into a *safer space*, a true reflection on our healing and our struggles. Calm introspection, communal trust, and feelings of warmth and joy permeated the gallery. Reflections on our daily struggles were met with support and validation, often through gestures rather than words.

One of the workshop's exercises had us abstracting the physical motions of our everyday labor of "caring for others" into gestures. We were then invited to resculpt the body of another participant to make an intervention into what they were sharing. Within my own movement, I held my arms out in what I was trying to express as a balancing act. My partner in this exercise (whom I had only met during the workshop), slowly resculpted my arms from a rigid cross into a gentle gliding motion, until they were down by my sides. The movement transformed the balancing act into an opportunity to imagine my arms as wings, and the freedom that comes with flight. Trusting the other participants in the room and being open to both share and receive were foundational elements of *safer-space creation* during the workshop. Two of the participants had simply walked into the space out of interest while the workshop was setting up, and decided to stay for the entirety, contributing their presence and participation openly. I believe that was only possible because of the environment of safety that was nurtured in the space and from what was visible of it from outside, making it a safer space for women from deeply rooted communities. For these two women in particular, yet also for the rest of the participants, this workshop provoked a rupture in our daily lives, and presented an opportunity for reflection and transformation.

Annick MF reflected on the workshop in a short, written piece she shared with me:

> As we held space, shared, practiced, and shaped community together, the participants and even my close co-facilitators were unaware that I was still in the midst of recovering from a 56-hour labor where I nearly lost my life. Unaware that I could barely sit due to my scarring or that I still had uncontrollable labor shakes every night that made me wonder if my body would ever be my own again. How many other stories of resilience and perseverance through hurt and fears were in this space without being named? Yet here we were together—healing from wounds unnamed, sharing practice, and shaping community. Participating in the care of us, as we always have, whether seen or not seen, for the stitchwork that keeps us linked and holds us together.

This workshop was one of the most impactful events during *TCOYS*. Perhaps this was due to the limited number of participants, or because I actively participated rather than facilitated it—a freeing experience that allowed me to be fully present. Handing the torch to the facilitators, I was therefore able to participate in something that I spent so much labor creating, and from that perspective, I was able to see *TCOYS* carry its own light and illuminate others.

Glavina explained that she chooses to avoid describing the labor of women as *invisibilized*, arguing that women's work is unacknowledged as labor not because it is unseen but because it is undervalued. By focusing on the undervalued labor of women and female-identified individuals in the community, the workshop allowed us, as participants, to reflect on our own roles as well as those of the women that make up our daily existence (mothers, sisters, teachers, and friends). The exercises that the three women facilitated effectively gave us tools to transform the often exhaustive work of caring for others into a supported self-care process, equivalent to community care. This process was reinforced by another artwork in the gallery, Narmeen Hashim's series *Hands that Heal*. The diptych, made up of two

watercolor-and-ink portraits of women's hands, was described by Hashim as an acknowledgment of the need for self- and community care to be incorporated into our collective duties as women of color.

The art on the walls was critically connected to the workshop's goals, creating a synergy between the gallery space and the workshop exercises. The act of reflecting on the experiences of women of color was a significant narrative thread throughout the exhibition. In celebration of their strengths in the face of unfathomable struggle, one of Joseph Cuillier's prints from the *Black Abstracts* series sums it up the best: "Raised by Black women in the company of Queens, I learned the wisdom of all man."

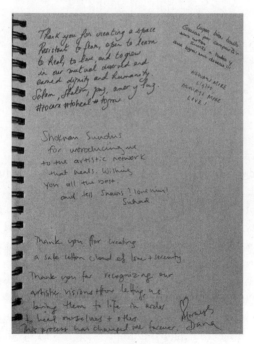

Guest book from *TCOY* exhibition

Suheir Hammad
@yosuheirhammad

@SundusAH habibti, am wondering
what self care feels like in #mosul, this
morning. love to the fam #bossa

12:27 PM - 30 Mar 2017

CHAPTER 5

SPACE

Safe(r) Space?

Baby, it's war outside these walls
Baby, it's war outside these doors, yeah
A safe place tonight
Let's play it safe tonight.

—Solange, "Borderline (An Ode to Self Care)"[1]

The idea and practice of creating "safe space" has been widely debated and discussed in many different contexts and situations, from classrooms to workplaces to art shows. Given the highly differentiated nature of power and space with regard to gender, sexuality, race, class, ability, religion, politics, and everything in between, it is not surprising that there is no consensus to whether spaces can actually be truly safe for all spectrums of identity or experience. Even the term *safe space* itself must be taken with a grain of salt and approached with caution. Can safe spaces exist in warzones or sites of active resistance, where the danger of dying, becoming injured or imprisoned exists in both private

1. Solange, "Borderline (An Ode to Self Care)," *A Seat at the Table*, Columbia Records, 2016.

and public spaces? Safe space, therefore, is a privileged notion. Regardless, it is important to unpack the challenges and possibilities for *safer space*, particularly in a cultural context. For me, safer space means inhabiting a space where you feel protected from harmful and triggering experiences that impact your mental, physical, emotional, and spiritual well-being. These spaces need to be free of the perpetuation of racist, sexist, patriarchal, homophobic, transphobic, classist, and imperialist thought and action. A high level of self-awareness and respect for others is necessary to create a safe environment.

In my studies of systemic violence and institutionalized racism, I have become more aware of my positionality as a white-passing Arab woman. Moreover, as an immigrant to Montreal, a place considered unceded Mohawk territory, I have tried to foster within myself an awareness of the struggles that First Nations people have gone through to make my life here possible. This positionality gives me the chance to reflect on how I identify within all these intersections. I have observed that many Arab people in North America don't identify as people of color, and that I may not be welcome to use it to identify myself either. As a term, "person of color" can be problematic depending on the context it is used, by whom and for whom, and in which community.

Within my own community, I am faced with the historical reality of Arab participation in the slave trade, anti-Blackness, and discrimination. My "otherness" is not as visible as some of my relations, however, my personal experiences with racism, discrimination, and sexism in white-dominated spaces have greatly influenced how I navigate society, the spaces I choose to inhabit, and the values I uphold. I am coming into the conversation on race, class, identity politics, and intersectionality as an ally as well as a subject. I believe that one can stand in solidarity with people of other struggles without trying to equate the various struggles or claim them to be the same. For example, it is important to note that the Black struggle in America is different from the Palestinian struggle, although they both suffer from systemic oppression and militarization in their daily lives.

Through transcultural solidarity, one can draw many parallels between the different experiences of struggle without having to paint them with the same brush.

My intention with curating *Take Care of Your Self* was to create a space defined by care, and I managed to somehow create a safer space for many of the artists and visitors to the gallery. Conceptually and thematically, the three-pronged approach to creating a caring and safe space in the context of diverse struggle had to do with collective empowerment, transcultural solidarity, and community care. Choosing to headquarter *TCOYS* in a pop-up gallery was also an empowering and liberating experience. It allowed me to work on my own terms, explore, and set my own standard of curation and storytelling through art and narrative. It allowed me to create a space for deeply rooted people, like me, where we can be surrounded by our radical ideas and celebrate our experiences, for us and also for a wider public. Not wanting to only "preach to the choir," and in turn also ruffling a few feathers, the impact of the exhibition went to unexpected places in audience reception due to the central location and the accessibility of the gallery, as a free-to-enter street-level space.

A public space for the stories and art of deeply rooted people therefore becomes accessible to community, neighborhood folk, passersby, and other potential audiences that a conventional gallery space would not necessarily attract. The transformation of a public space into a safer space is challenging. Encounters with racism happened throughout *TCOYS*, both inside and outside the gallery space, some even related to the work exhibited. We had many passersby enter the gallery and spend a minimum of twenty-to-thirty minutes discovering the work and being in the space. Our many intentional visitors would often spend close to an hour connecting deeply with the works and sharing feedback and testimony. Both the artist talks and closing panel had audiences that filled the seating capacity (over forty). Several out-of-town artists made their way to Montreal specifically to be present at the vernissage and the artists' talks, because of the nature of the event

and the power of cultural convening in the context of struggle and self-care. Local artists were often present at the gallery space as well, which really felt like a headquarters of sort for our small yet strong community of artists of color.

As part of the process of creating a "safer" space in the gallery, I turn to my own experiences and expectations of how I can feel safe in the context of an art show. In learning to cope with my own trauma, I initially thought that sharing personal experiences through my art practice and in artists' talks might help me to heal. However, I learned (the hard way) that talking about it and sharing it alone didn't help. In fact, it made me feel depleted and exposed. This reflection on the creation of a safer space for myself led me to take the approach I took with both the artists and the audience. Rather than encourage anyone to testify or share their traumas, I encourage artists to share different ways of coping, self-care strategies, mental health resources, or to simply relate and hold space. Over the course of the week, the storefront gallery became a space of reflection, healing and community for artists, visitors, and participants.

Due to the concepts of loss, trauma, and struggle that many artists explored in their works, I was conscious of potentially triggering anxiety or difficult emotions in the audience. For this reason, I printed pamphlets of mental health resources in Montreal and placed them discreetly near the gallery's entrance, as well as on the merchandise table at the back of the gallery. This list was originally compiled by Monster Academy, an on-line mental health skill-training project for Montreal's youth. I was granted permission to adapt their material into a pamphlet for free distribution at *TCOYS*.

The pamphlets were an invitation for visitors to seek out support, should they be suffering from mental health issues, as often, the hardest part of seeking help is not knowing where to begin looking. During the vernissage, I staged a ten-minute breathing exercise and guided meditation facilitated by Iraqi-Canadian yoga and Pilates instructor Marwa Al-Mubarak. The intention behind such interventions is to offer coping strategies audiences can take home with them. It was also an

opportunity to ground ourselves in the present moment. I believe that experiencing art has the powerful potential to channel strong emotions, as each artwork carried with it an opportunity to inspire and impact the viewer. Finally, the act of convening amongst people with shared experiences in itself can be healing.

The Challenges We Face

Without community, the effort of creating safer spaces is futile. The risks involved are many, especially when such interventions take place in the public sphere. Moving within cultural institutions that are often homogenous, finding spaces for the art, stories, and experiences of society's most marginalized groups is a difficult and daunting task. Taking the risks necessary to create (temporary) cultural spaces that champion the experiences of deeply rooted communities is a tactical response to the hegemonic and rigid representations of those experiences. With the limited space available for people who experience marginalization in major (and minor) art institutions, independent projects such as *Take Care of Your Self* and its curatorial counterparts offer new narratives to the existing canons authored about the experiences of marginalized groups by those outside of its sphere. Choosing to focus on the intersectionality of struggles within diverse deeply rooted communities, *TCOYS* was an exercise in the healing potential of transcultural convening. The politicization of self-care, in the context of such convening, was an opportunity to transform struggle into empowerment.

Independent curatorial projects often face many challenges that can otherwise be avoided or lessened should they take place in an established gallery or institution. Securing funding, scouting locations, finding sponsors, catering, creating and distributing promotional materials, and other logistical elements can be an exhausting endeavor. However, I am acutely aware of the tensions between independent curation and affiliating with an established museum or gallery. The pros and cons involved are many. I am not yet certain that a care-full approach

to curation, with the ultimate goal of creating a safer space for people who experience marginalization, can exist outside of the margins. I'm also not certain if it is necessary to create such spaces in the center at all.

How to create a safer space in public space is a question I grappled with throughout my research and practice. Small gestures can make big impacts, such as my practice of offering tea to the visitors, inviting passersby inside, and engaging in meaningful conversation in the space privately. To illustrate the complexities behind creating safer spaces, I recall an uncomfortable experience I had during *Take Care of Your Self.* Two doors down from the pop-up space was a business owned and run by a woman who was known to the neighborhood as a racist, with many people of color experiencing racial slurs, aggressive behavior, and threats by her both inside her shop and outside of it in public space. Her threats to call the police, filming our convening with her cellphone camera, the dirty looks and racial slurs made the space outside the gallery doors feel unsafe. This feeling made me realize the mere act of claiming our own space for our ideas and work to live in was as radical and important as the work that were on the walls.

Most of the time, the gallery became a community space of sorts, with many of the exhibiting artists passing by and spending time there, as well as other community members visiting multiple times. There were often children, my own and others, who came with their parents. The gallery was animated by our shared experiences of community and empowerment, and turned into a safer space where people who have experienced marginalization could gather and be together, meet others, and convene.

On the sixth day of *TCOYS*, we hosted a Palestinian-Canadian Masters student who had just endured a difficult experience as a subject of Israeli oppression and Canadian complicity in that oppression. She had gone to Gaza to visit family while pregnant with her first child, and when it was time to return to Montreal, the Israeli government refused to issue her an exit permit. She found herself stuck in Gaza and was forced to give birth to her child there, under difficult circumstances.

"Stronger
together"

The Canadian government refused to intervene in her case, al-
though she was a Canadian citizen and had her entire life as a
student and resident in Montreal effectively put on pause. Her
experience represented so much of the struggle that marginal-
ized women face in light of systematic oppression and how it
interferes with our every movement and freedoms. While we
were speaking to the young mother, a white woman came in
and aggressively demanded, in French: "How can you have an
intercultural exhibition in Quebec without French and with-
out Quebecois artists?" She was visibly upset and stormed out
before we could engage her in conversation. I was left feeling
shocked, however, I was not surprised that the narrative of lan-
guage and inclusion had entered the gallery, especially in the
context of Quebec's language laws, reasonable accommodation
politics, and so-called religious symbols ban. The young woman
we were hosting was wearing a hijab.

About an hour later, two white men came in and stormed out
quickly after being "confronted" by Ahmad Naser-Eldein, Leila
Abdelrazaq and Aura's works, which were all representations

of the Palestinian, Black, and Indigenous struggles. The men were visibly angry and the only word I managed to pick up before they barged out of the gallery was "*autochtone*" (French for Indigenous).

I journaled the experience when I returned home that evening:

> When those men came in (and left), I was alone in the gallery, and I immediately felt unsafe. It was a feeling like no other, just being exposed and unsupported. None of my friends and community members were nearby. What if they come back and get aggressive? There I was, in all my othered glory, with all my radical ideas and proud marginal existence. Alone.
>
> So now I understand the value of community. We are power in numbers. We are stronger together. We protect each other. We hold each other down. We lift each other up. We support each other, we defend each other. We keep each other safe. That has been the most prevalent feeling when I am in this space, and many of the people who have come in have remarked on that energy and picked up on that atmosphere.
>
> I now acknowledge the challenges of the public nature of this exhibit. Being a storefront, street level, central location, will not only bring in the people you want to attract—aka community, all classes of people, people who would not necessarily visit an art exhibit, it will also bring in the people who you do not want to attract—aka racists, bigots, and closed-minded people.
>
> I closed the gallery early today because I did not feel safe.

Behind the Scenes

The direct experiences with racism and discrimination were in total contrast to most of the feedback I received over the course of the week from visitors and artists of all backgrounds about the creation of a safer space. One visitor described her visit as a sort of "pilgrimage," and out of sixty-six entries in the gallery

guest book, fourteen of them directly reference the creation of a safer space. This means that these kinds of spaces are badly needed and are few and far between. One visitor wrote: "A healing space is not always easy to find or even create. Thank you for bringing all the voices together here. . . . Much needed!" Likewise, another visitor wrote: "The space created here is warm and comforting and needed. It's the first step to healing our communities. Thank you for creating this space." Reading these comments and others in the guest book reaffirmed the need for safer spaces like *TCOYS* to exist in both communities and the art industry, effectively bridging a void in both milieus.

To remark on whether an exhibit such as *TCOYS* can be sustainable, I think it's important to make visible the details of what takes place behind the scenes. First and foremost, it is important to note that for this particular project, I was able to secure most of the funding through academic sources because the project was related to my studies. I was able to bring on board local businesses as sponsors, in order to manage costs related to printing, framing, and catering. I also approached the company that rented the pop-up space to reduce the cost of the rent by coming on board as a sponsor. As it was a non-profit event, the more support I got from my community, the more I could pay the artists and cover costs related to their needs, like the shipping of the artists' works, material costs, and travel costs. It was a priority for me that none of the artists pay out of pocket for their participation in the show. As an artist-curator, I know the sacrifices that come with the decision to be an independent artist, so it was important for me to practice fairness and transparency. I was flexible with deadlines and maintained professionalism throughout the process. Difficult experiences with anyone involved were met with compassion and consideration to the complicated inner lives we move within.

The artworks and custom-made merchandise were for sale, with a 30/70 split to the artist. The show was covered by local media in Montreal, from radio, print, and Web-based venues. All the events were free. All the open events were filled to

capacity, and we welcomed several hundred visitors in total over the course of the week.

In the end, I was able to cover all costs without incurring any losses, but also without making any profit. And that's okay, because that was never the intention behind the work. However, another challenge we face is how to make our practices sustainable in the circumstance that external funding sources are not available to us. Here again, we must be imaginative and industrious in considering other avenues for funding and sustainability to see through independent projects till the end, such as crowdfunding, event-based fundraisers, merchandise sales, and radical philanthropy.

The closing of *TCOYS* on the eighth day was bittersweet. I, along with my family, friends, fellow artists and community members who were invested in *TCOYS*, were sad to see it go. We knew that the end of *TCOYS* also meant the end of a community space where we convened and felt safe together, accessing the reserves of self-care and healing filling the space and animating the walls. The presence of art spaces that are sites of community and empowerment are temporary, unfortunately. There has yet to be a permanent site for such convening, in the context of art, at least in Montreal. I believe it to be possible, sustainable, and scalable. The continuing work involved in building and creating safer spaces for our work and narratives to exist lies ahead of us.

Take Space, Make Space

To truly think outside of the "white box" of the gallery space, we must be imaginative when it comes to creating spaces for art, particularly with an anticapitalist approach to work. The possibilities—and challenges—are endless, however that must not discourage us from conceptualizing new ways for people to experience art. Public, private, and online spaces have limitless potential. A street-facing window or balcony in a private residence can display art, and a public park or street corner can be a site for an artistic intervention. We are well accustomed with

online spaces for art circulating all over the Internet. However, when you add a community-focused platform to the mix, interesting opportunities arise.

In 2019, FADAA was launched as an online platform to connect artists and hosts of various spaces. With no money exchanged, it would bring forth:

> a new economy based on shared spaces and the values of freedom of expression and open societies. FADAA enables individuals and institutions to temporarily donate spaces and facilities around the world to be used and reused by artists and those who support them, cultivating an environment where creativity and communities thrive by supporting one another in a grassroots ecosystem.[2]

FADAA was founded by Sudanese political cartoonist Khalid Albaih, with a vision to bring the culture of sharing that he grew up with to artists and communities around the world. The word *fadaa* means "space" in Arabic. FADAA points to a transformative movement within the art industry that has accessibility and community at its core. With no exchange of money, the relationship between space sharing and art-making becomes woven into society and community, outside the purview of economy and class.

Naturally, when I think about care-full curation, what first comes to mind is finding an appropriate space. It is the first and most important step. However, there is so much more substance to space than physical (or digital) walls. Here are six elements relating to space that were foundational to my process of care-full curation, which I hope can inform others who take on similar curatorial projects:

Create space. With intention and an independent spirit, any curatorial project can be creatively executed. In many cases, artists and curators are limited by gallery spaces either charging exorbitant fees for rental, or a long and unpredictable process of applying for gallery programming for the following year. However, there are multiple avenues to pursue, such as renting

2. For more information, see getfadaa.com.

a short-term pop-up space, holding a one-night-only event, staging public art interventions, or even curating spaces online.

Safe(r) space. The space we create is sacred; and it is for us, by us. It should not traumatize, trigger, or make anyone feel threatened because of identity or self-expression. No racism, no sexism, no homophobia, no transphobia, no ableism, no xeno-phobia, no fatphobia, no ageism, no classism, no Islamophobia, no anti-Semitism, no bigotry, no hate, no violence. More care.

Hold space. Grieve together, heal together. To give our stories the room to exist, we must really just hold them and stay with them. Let them linger, in us, and in that space. Honor the stories and the people who tell them.

Accessible space. A space that is wheelchair accessible, open to all ages, with an area for children, and most importantly free of charge is absolutely necessary. Accessibility also means that people of all classes should feel comfortable in your space.

Community space. A space would be bare if there were no bodies, emotions, souls, and conversations happening within it, because of it.

Marginal space. Exhibitions don't need to take place in a major gallery or institution in New York, Los Angeles or London. The margin can be a very empowering and freeing space. Existing outside of the canon and the mainstream, marginal space makes its own rules and defines its own terms.

CONCLUSION

Throughout the writing of this book, multiple events have taken place around the world that reaffirm the need for systemic change. From the revolutions in Iraq, Lebanon, and Sudan, to the worldwide health crisis, to the Black Lives Matter movement, and the growing movement for Indigenous sovereignty on Turtle Island and South America, the call for justice couldn't be louder. The struggles of people around the world, as different as they are, are moving in the same direction: towards liberation from colonial, capitalist, imperialist, and militarized systems of power. The disproportionate amount of power wielded by corrupt governments and corporations has reached its pinnacle. We are on the eve of a great shift, and it is more important than ever to practice care on individual, community and global levels in the struggle for real, lasting liberation.

The artist has a deeply significant role in times of social change. As Emory Douglas explained to me during our interview, art is a language and a very powerful visual tool that transcends borders and boundaries. Art is universal in communicating messages, and can be a very enlightening, informative, and transformative tool. The artists who are engaged in resistance, healing, and care are our guides moving into an uncertain

future, because they have been carefully crafting new narratives and imagining different ways forward for us to draw strength and power from in these trying times.

For art to reach its potential in this regard, it must be accessible. This book is a reference for the kinds of projects and spaces we need as transcultural beings caught in the web of rigid institutional culture and sanitized sites of self-care. It imagines an art industry independent from the colonial construct, a curatorial approach that is more care-full, and spaces that are safer. My own experience curating *Take Care of Your Self* was by no means perfect. I know that there are things that I will do differently in the next iteration, especially as the world changes and shifts. However, it is a foundation for the exploration of the intersections of care and struggle, illustrated by artworks from a most inspiring group of artists, and narrated by the conversations they bring forth.

Although the practice of self-care has reached mass appeal, I still find myself questioning intention. What good is self-care, really, if it isn't used for self-awareness, community building, and reaching towards liberation? What good is self-care if its practices hurt the planet, or if it's indifferent to the struggles of the world and the question of privilege? What good is care if it perpetuates systems of oppression, erasure and appropriation, and actually works to strengthen destructive capitalist markets? What good is care if it continues the same cycle of greed, white supremacy, and colonial class structures that continue to hurt the people who most need self-care practices?

For care to be truly transformative, it must be decolonial and intentional. For those of us who have experienced systemic oppression, care and well-being become acts of radical resistance. Joy becomes a weapon. Imagination becomes medicine. Care becomes revolutionary. The spirit transcends the physical and material. We were never marginal; we are expansive.

When I wrote the story of Shams, the little girl made of glass, after a night of insomnia, I could have easily stored it away in some folder on my laptop and forgotten about it. Instead, I allowed myself to pursue it. If I hadn't, the book you are holding

in your hands would not have materialized. The act of creation can be transformative, if you allow it to be. So, I encourage you to consider how your acts of care can become positive catalysts for these larger issues of self, community, and the world.

It all starts with sharing your story.
Do it for your ancestors and for the future generations.

Read.
Write.
Make art.
Play music.
Organize an event.
Curate an art show.
Control your screen time.
Make time for your elders.
Play.
Pray.
Practice Gratitude.

And while you're at it, remember to breathe.

Stop.

Breathe.

Breathe from your nose, into
your stomach, let it expand.

Let your exhale be longer than your inhale.

Suheir Hammad
@yosuheirhammad

bless the care needed, bless the care givers.
#bossa

8:45 AM - 24 Jul 2013

EPILOGUE

Care and the Pandemic

In the age of pandemic, the phrase "take care of yourself" has taken on a completely new meaning. We are now aware, on a global level, that health—physical and mental—reigns supreme.

Over a century ago, my great grandfather Abdul Hadi, my namesake, and his wife Taqiya, died together from the bubonic plague in Iraq. They left behind their three orphaned children, one of whom is my grandfather Taqi, who lived a full life and fathered six children, including my father Taghlib. I write this as a daughter of survivors, in honor of my ancestors who left behind a living legacy of which I am a part. As the first generation from my lineage born outside of Iraq, I was spared living through the wars of the past three decades. I have been privileged to live a life of relative safety, untouched by curfews, school closures, lockdowns, states of emergency, controlled mobility, mass casualties, and the everyday dangers of a life-threatening enemy. Until now. The global COVID-19 pandemic feels a lot like a war that knows no borders and exposed a lot of injustice and inequality in the process that we simply cannot ignore anymore.

What a time to be alive. Looking back at the major events of the past year, my mind turns to the revolutionary movements

that have sparked across the world—the nations and communities struggling for liberation. I think of the climate crisis and Indigenous land and water protectors. I think of the trauma that followed after the catastrophic—and negligent—Beirut explosion. I think of the systematic murders of Black men, women, trans and gender-nonconforming folks in the United States by the hands of the police, and the words, "I can't breathe." I see the connections between all of it—the pandemic, the climate crisis, government corruption, systemic racism, and the global revolutions. All of these major events are crying out for one thing: radical change of our habits and oppressive power structures. One of the symbols of the revolutions in Iraq, Lebanon, Hong Kong, and elsewhere was the blue surgical mask that protestors wore to protect themselves from the suffocating tear gas incessantly thrown into the crowds to disperse them. Now, people around the world wear those blue surgical masks to protect themselves from the coronavirus, which also attacks the breath. In November of 2019, I made an artwork reproducing the iconic "Mask of Warka," the Sumerian bust presumed to be a depiction of the goddess Inanna, wearing a blue surgical mask. It was a humble artistic offering in support of the protestors in Iraq, and a nod to our ancestors and their ever-watching eyes. A few months later, the symbolism of the blue mask has taken on a completely different meaning. It has become a universal symbol of personal protection against an invisible virus that has completely shaken our world. As the world has changed, so has the meaning of the artwork and its symbols.

As I write this in the summer of 2020, I wonder how the meaning of this book will change and transform as well, as it was written in a pre-pandemic world. My thoughts on care revolve around art and culture, and how we can practice care in our communities as artists and cultural producers. A big part of that process involves imagining alternate narratives to the existing conversations being had about care in our various "industries." Because there is so little space for care in capitalism, I've become resolved in my determination to struggle for collective and systemic change. Luckily, I've been contemplating

this long before the pandemic, so perhaps I can offer myself some solace (or not): I've never liked change. Actually, change makes me anxious. We've suddenly been thrust into a changing world that is plagued with panic, fear, and anxiety. Turn on the news, scroll through Twitter, read headlines, tap through stories. It's overwhelming to even think about the mass amounts of information, opinions, stories, and theories circulating in our environment.

There are so many layers to the changes we are experiencing. PTSD and trauma are impacting the lives of many frontline workers. Grief and loss have shaken the lives of many people who have lost loved ones to the virus. For those of us who already struggle with our mental health, it can be completely debilitating. The pain is palpable. While I have gratitude for the journalists and media machines churning out necessary information to the masses, I am acutely aware of the culture of fear the media also engages in. As an Arab Muslim who lived through September 11 and the long "war on terror," I know the media can really be *careless*.

For some of us, with our consumer habits and industries on pause, what we thought was "normal" is now feeling excessive, exploitative, and unsustainable. The capitalist systems and concepts we perceived as unchangeable and rigid have been collapsing like paper towers. The virus has exposed many of the systemic injustices along lines of racial, class, and economic inequality. Perhaps we knew this all along, but now it's clear as day. We cannot go back to our old "normal." We are faced with an opportunity to shift our narratives and our systems.

Pandemics and plagues have a history of sparking systemic change, such as the fall of feudalism in the fourteenth century after the Black Death and the ensuing Peasants' Revolt.[1] By reflecting on the global revolutions that defined much of the past decade, I realize that the revolutionaries were onto something and the rest of the world is late to the party. Our systems are

1. Paul Mason, "Will Coronavirus Signal the End of Capitalism?" *Al Jazeera*, April 3, 2020, https://www.aljazeera.com/indepth/opinion/coronavirus-signal-capitalism-200330092216678.html.

broken. It's time for radical change, spearheaded by the wide-spread need for justice, collective care, and well-being.

Despite the grief and uncertainty, this pandemic has brought the subject of care to the forefront. Health-*care* workers are our heroes. The health-*care* system is the most important system we have. The people who keep us fed—the farmers, truckers, grocers, and delivery people—are *essential*. The janitors and cleaners sanitizing our spaces are *essential*. Bus drivers and postal workers are *essential*. The homeless deserve care, the elderly deserve care, the abused deserve care, vulnerable communities deserve care—prisoners also deserve care. These are just some of the social issues that have been coming up in conversations on care as a result of the pandemic. The underlying mechanism behind social distancing is *care*; protecting yourself and therefore protecting others from spreading the virus. We are all doing our part, I hope, in practicing community care to protect the most vulnerable members of our society from illness and limiting the spread of the virus. The concept of collective well-being, and how one person can make an impact on his/her/their community, is now reaching critical mass. This is self-care and community care in action. This is change I can get behind.

I don't know whether we will end up finding ourselves in a dystopian future, surveilled by the very devices that give us pleasure and connection, or in an Indigenous future that sees a return to respect and gratitude to our environment and our communities. What I do know is that we are on the brink of major change. I hope that this book can become a catalyst for change in its own small way, in allowing us to think about how care can be transformative and revolutionary in all its forms.

Our Ancestors Are Watching
By Sundus Abdul Hadi / Digital collage, 2019

APPENDIX

#Arabs4BlackPower Statement

September 2016

We, the undersigned artists, academics, mothers, fathers, students, refugees, and community organizers with ties to Arabic-speaking regions, declare our unwavering solidarity with the Movement for Black Lives (M4BL). We fully and wholeheartedly endorse the policy demands put forth by the US-based Movement for Black Lives platform and its transnationalist vision for Black power, freedom, and justice. We join you in reiterating the necessity of shared struggle and collective liberation of all oppressed and Indigenous people globally. For liberation to be real and genuine, we all need to get free.

The current iteration of the movement to end the war and genocide against Black people in the US is rooted in centuries of the Black freedom struggle. As we commemorate the month of Black August and its history of radical resistance, we as #Arabs4BlackPower commit to amplifying the rebellions of Black and Indigenous people in the settler-colonies of the Americas; and to joining in the fight against white supremacy, patriarchy, and hyper-militarized late capitalism.

Once again, Black people in the US are defending themselves from the violence inscribed in the Americas' settler colonialist regimes built on the backs of Indigenous, Black, and Brown people through the expropriation of Indigenous lands, genocide, and slavery. Once again, Black freedom fighters are refusing colonial and imperial narratives that uphold white supremacy and are continuing to craft a language rooted in the struggle for justice. Once again, Black liberation movements are challenging systems of criminalization that dehumanize, incarcerate, and assassinate Indigenous, Black, and Brown people—systems that simultaneously transcend and reinforce national boundaries through border-control complexes to terrorize people around the world under the umbrella of the global "war on terror." And once again, Black organizers in the US have put forth a vision to continue imagining and transforming these systems within and across borders.

The US empire violently exerts control over Indigenous, Black, and Brown communities internally and around the globe. People in predominantly Arabic-speaking regions experience empire in locally specific material forms: bombings, drone strikes, forced disappearances, checkpoints, carceral wars, forced migration, Indigenous displacement, starvation, the theft of natural resources, apartheid, and more. The

geography of Ferguson to Palestine is integral to #Arabs4BlackPower charting the structural connections, albeit different manifestations, inscribed by the US-led "war on terror." It connects anti-Blackness as well as anti-Muslim and anti-Arab racism in the US with global imperial wars in the rest of the world.

The "war on terror" rests on regional geopolitical alliances forged for the sole purpose of maintaining and furthering imperial and Zionist hegemony. It is situated within a genealogy of colonial legacies that have structured power in Arabic speaking regions along the lines of gender, religion, ethnicity, skin color, language, and sexual orientation, to name a few. With these genealogies in mind, those of us struggling to rid all communities of the Maghreb and the Mashreq[1] from militarization and neoliberalism must center the lived experiences and aspirations of women, Black Arabs, Nubians, Imazighen, Kurds, Armenians, migrant workers, refugees, gender-nonconforming individuals, queers, and others. We pledge to work against marginalization within our communities in all its forms and to continue examining the language we use as we continue dismantling colonial legacies. We must refuse and erase national boundaries created to divide us—building with the oppressed from Palestine to Western Sahara, from Yemen to Syria, from Algeria to Sudan, from Tunisia to Egypt and beyond, as we come together in solidarity with the Movement for Black Lives.

In pledging to resist and overcome, we as #Arabs4BlackPower unequivocally support the M4BL platform for reparations, invest-divest, economic justice, community control and political power. We recognize, as did many before us, that only through joint struggle will we dismantle the distinct yet intersecting systems that both oppress Black and Indigenous people in the settler colonies of the Americas and institutionalize a war of terror from within US boundaries to the Mashreq, Maghreb, and beyond. To this end, we commit ourselves to combating anti-Blackness wherever we find it in our communities—both within the boundaries of the US as immigrant-settlers complicit in white supremacy, as well as in Arabic-speaking regions where socio-historically distinct forms of discrimination against Black Arabs intersect with other forms of marginalization along the lines of gender, religion, ethnicity, skin color, language, and sexual orientation to name a few.

From Ferguson to Palestine: we will work for liberation.

To everyone building towards the Movement for Black Lives: We see you. We hear you. We stand with you.

In joint struggle,
Signatories

1. Maghreb and Mashreq are locally referenced geographies within predominantly Arabic speaking regions, spanning from the Maghreb (Western Africa) to the Mashreq (Eastern Africa and Western Asia).

Take Care of Your Self Curatorial Statement

July 2017

Take Care of Your Self. How many times a week do we hear or say these words in passing? If we all took the time to care for ourselves, how much stronger will we be? More importantly, how much stronger will our communities be?

Self-care is a community act. For those of us experiencing loss and displacement, self-care is a necessary act. The politicization of self-care has emerged from the collective witnessing of structural racism and oppression on both social and global levels. It is an intervention, as well as a rupture in the ongoing struggles for rights, freedoms and well-being. It is in those ruptures that interesting things manifest, just as in the margins.

The works in the exhibition are not meant to heal as much as they are (or were) tools in the process of healing. Healing happens from within, and it's hard work. In healing work, it is often said that things will get worse before they get better. The works on these walls are reflections on struggle, whether personal, political or social, by artists of diverse communities. **Arab, Black, Indigenous, Brown, Muslim, "Other": We hold this space by grieving and healing together.** We celebrate struggle and otherness, because oftentimes, those two experiences are synonymous. We empower our traumas by our healing, because that's the only way we know how to.

This exhibit is a testament to how notions of self-care, self-determination, and healing have conceptually informed the work of artists dealing with complex issues of struggle since the founding of the Black Panther Party and the art of Emory Douglas. Finding the intersections of all of our struggles is crucial, whether on racial, gender, structural, and/or class lines. There is no hierarchy to struggle, and the margins are rich with our complex, intersectional diversity.

Take Care of Your Self is a deliberate act in the politicization of self-care in order to better resist, or persist, in the struggles for rights, freedoms and well-being. Illustrated by the works in this exhibit, the heavy subjects of trauma, loss and displacement can transform into opportunities for healing and empowerment, foregrounding the concept of self-care at the forefront of the discourse on struggle.

ACKNOWLEDGMENTS

Shukran | Thank you

Al Hamdulilah. All praises due to Allah.

Writing this book in the trenches of motherhood during a pandemic and multiple major global events has been extraordinarily humbling and challenging. I would like to extend my deepest gratitude to the people in my life who took care of me and who contributed their spirit, art, and words to this book.

To my parents, Sawsan and Taghlib, for instilling in me the desire to seek knowledge and to create art. To my sister, Tamara, for being an inspiration in life and art. Their support and encouragement is the foundation beneath my entire being.

To my husband and soul mate, Yassin, for whom there are no words to describe the extent of his impact on my life.

To my children, Shams and Yusra, who have chosen me to be their mother and transformed me. I do it all for you.

To my teachers, Nawaf Al Rufaie and Suheir Hammad, who have carved new pathways in my mind where I have found the greatest sources of knowledge.

To the Communications Department at Concordia University for being the only academic space I ever felt safe in, thanks to Yasmin Jiwani and Elizabeth Miller's care and gentle guidance.

To Emily Jacir and Suheir (again), for paving the path for a young Arab artist and for their generosity of spirit with their involvement in this book.

To the artists: Ahmad Naser-Eldein, April Banks, Monique Bedard (Aura), Dana El Masri, Emory Douglas, Jessica Powless, Jihan Kikhia, Joseph Cuillier, Julay "Sacred Spirit Ink" and Allos Abis, Leila Abdelrazaq, Narmeen Hashim, Niti Marcelle Mueth, Nora Patrich, Roï Saade, Sadaf Rassoul Cameron, Samira Idroos, Shanna Strauss, Soukayna, Suhad Khatib, Susu

Attar and Tara Jaffar. This book would not have been possible if not for your art and vision. To Marwa Mubarak, and to the workshop facilitators behind "Taking Care of Us": Jess Galvina, Teeanna Munro, and my dear friend Annick MF.

To Malav Kanuga and the team at Common Notions who worked with me on developing and editing the manuscript into the book you are holding.

To Suhad Khatib, for her perspective as my concept editor. Her feedback took the work to the next level, encouraging me to share the knowledge accumulated from all aspects of life, spirit, and art, and not to hold back.

To my soul sisters on this path: Hala Alsalman, Farah Kaysi, Zee Hassoun, Eleni Giannopoulos, Jade Heilmann, and again Susu, Samira, and Narmeen.

With deep gratitude to my soul brothers: Nawar Al Rufaie, Stefan Christoff, Sol Guy, and again Roï and Ahmad.

To my elders—my Bibis, Khalas, Ammas, Amus and Khaloos.

I am because of my ancestors.

BIBLIOGRAPHY

Abdul Hadi, Sundus. "Iraq is Healing: The October Revolution, Systemic Change and Intergenerational Trauma." *Medium*, November 16, 2019. https://medium.com/@WATM/ iraq-is-healing-the-october-revolution-systemic-change-and-inter-generational-trauma-2d8bc798901e.

Albaih, Khalid. "We used our art to fight. Now we need it to heal us." *Quartz*, June 19, 2019. https://qz.com/1647050/ sudans-artists-need-to-address-the-trauma-of-protest/.

Alsalman, Yassin. "Life Science." In *Text Messages*. Chicago: Haymarket Books, 2020.

Ardalan, Nader and Laleh Bakhtiar. *The Sense of Unity: The Sufi Tradition in Persian Architecture*. Chicago: University of Chicago Press, 1973.

Attar, Susu. "*ICONIC Black Panther* Art Exhibition." *Medium*, April 11, 2017. https://medium.com/@susu.attar/ iconic-black-panther-art-exhibition-ae11ace38943.

——— and Sundus Abdul Hadi. "Counterparts in Conversation: A panel discussion between Sundus Abdul Hadi and Susu Attar at *Take Care of Your Self*." Interview by Yassin Alsalman, July 14, 2017.

Baldwin, James. *Notes of a Native Son*. Boston: Beacon Press, 2012.

Bambara, Toni Cade, ed. *The Black Woman: An Anthology*. New York: Washington Square Press, 2005.

Berceli, David. "Reframing the essential role of tremoring and/or shaking as a result of traumatic or stressful experiences." Presented in online conference "Tracing Trauma: On the Science & Somatics of Healing Trauma," April 12–14, 2019. https://www.embodiedphi-losophy.org/tracing-trauma.

Collins, Patricia Hill. *Black Feminist Thought: Knowledge, Consciousness and the Politics of Empowerment*. New York: Routledge, 2015.

Davis, Angela. *Freedom is a Constant Struggle: Ferguson, Palestine, and the Foundations of a Movement*. Chicago: Haymarket Books, 2016.

Douglas, Emory and Sam Durant. *Black Panther: The Revolutionary Art of Emory Douglas*. New York: Rizzoli International Publications, 2014.

Douglas, Emory. Interview by Sundus Abdul Hadi on collective empowerment and transcultural solidarities, December 2016.

Fanon, Frantz. *The Wretched of the Earth*. Translated by Richard Philcox. Cape Town: Kwela Books, 2017.

Gumbs, Alexis Pauline, China Martens, and Mai'a Williams, eds. *Revolutionary Mothering: Love on the Front Lines*. Oakland, CA: PM Press, 2016.

Hammad, Suheir. *ZaatarDiva*. New York: Cypher, 2005.

hooks, bell. "Choosing the Margin as a Space of Radical Openness." *Framework: The Journal of Cinema and Media* 36, no. 36 (1989): 15–23.

Jiwani, Yasmin. "Pedagogies of Hope: Counter Narratives and Anti-Disciplinary Tactics." *Review of Education, Pedagogy, and Cultural Studies* 33, no. 4 (September 2011): 333–53.

Jiwani, Yasmin. "In Visible Colours: A Critical Perspective." *In Visible Colours: International Women's Film/Video Festival Brochure.* Vancouver, BC: Vancouver Women in Focus Society and National Film Board, 1989.

Kaz, Donna. *PUSH/PUSHBACK—9 Steps to Make a Difference with Activism and Art (because the world's gone bananas!).* Printed by the author using iBooks, 2020.

Kester, Grant. *Conversation Pieces: Community and Communication in Modern Art*. Berkeley: University of California Press, 2013.

Kimmerer, Robin Wall. *Braiding Sweetgrass: Indigenous Wisdom, Scientific Knowledge and the Teachings of Plants*. Minneapolis: Milkweed Editions, 2014.

King, Thomas. *The Inconvenient Indian: A Curious Account of Native People in North America*. Toronto: Doubleday Canada, 2017.

Lad, Vasant. *The Complete Book of Ayurvedic Home Remedies.* New York: Three Rivers Press, 1999.

Lang, Cady. "8 Things to Know About Solange's Super Secret Guggenheim Performance." *Time*, May 19, 2017. https://time.com/4786319/solange-guggenheim-performance/.

Leigh, Simone. "Simone Leigh: The Waiting Room." The New Museum of Contemporary Art, New York City, June 22, 2016–September 18, 2016. https://www.newmuseum.org/exhibitions/view/simone-leigh-the-waiting-room.

Lorde, Audre and Sonia Sanchez. *A Burst of Light: And Other Essays*. Mineola, NY: Ixia Press, 2017.

Mason, Paul. "Will Coronavirus Signal the End of Capitalism?" *Al Jazeera*, April 3, 2020. https://www.aljazeera.com/indepth/opinion/coronavirus-signal-capitalism-200330092216678.html.

Mbembe, Achille. "Frantz Fanon and the Politics of Viscerality." Delivered as keynote address for the Frantz Fanon, Louis Mars, & New Directions in Comparative Psychiatry Workshop, Franklin Humanities Institute at Duke University, April 26–27, 2016. Available at https://www.youtube.com/watch?v=lg_BEodNaEA&t=2989s.

Mehl-Madrona, Lewis. *Healing the Mind Through the Power of Story: The Promise of Narrative Psychiatry*. Rochester, VT: Bear & Company, 2010.

O'Neill, Paul. *The Culture of Curating and the Curating of Culture(s)*. Cambridge, MA: MIT Press, 2016.

Reilly, Maura. *Curatorial Activism: Towards an Ethics of Curating*. London: Thames & Hudson, 2018.

Rutherford, Jonathan. "The Third Space: Interview with Homi Bhabha." In *Identity: Community, Culture, Difference*, edited by John Rutherford. London: Lawrence & Wishart, 1990.

Said, Edward. *Culture and Imperialism*. London: Vintage Books, 2007.

———. *Orientalism*. New York: Vintage Books, 2003.

Shabout, Nada M. *Modern Arab Art: Formation of Arab Aesthetics*. Gainesville: University Press of Florida, 2015.

Van der Kolk, Bessel. *The Body Keeps the Score: Mind, Brain and Body in the Transformation of Trauma*. London: Penguin Books, 2015.

GLOSSARY

Artist-curator: An artist that curates; a curator who is also a practicing artist.

Care-full curation: An approach that centers care and decolonizing work in curatorial practice.

Community care: To intentionally make positive impacts on the people in your surroundings by uplifting and empowering them and tending to their needs.

Collective consciousness: Sharing fundamental beliefs, values, and thoughts across all levels of society.

Counternarratives: Alternate representations, depictions, and/or definitions to existing harmful mainstream portrayals of a subject or people. Also, a stereotype-breaking alternative to many of the destructive narratives that have worked to misrepresent, render invisible, vilify, oppress, or erase the diverse struggles and experiences of deeply rooted people.

Decolonization: A difficult, laborious yet necessary process that deeply rooted individuals and communities must undergo in order to achieve liberation from oppressive colonial impacts on all aspects of self, society, economy, politics, and culture. Decolonization must happen on both individual and collective levels and is rooted in self-determination, empowerment, and critical thinking.

Deeply rooted: An empowered word to describe any person or community rooted in an ancient culture steeped in traditional and Indigenous knowledge that colonization attempted to erase. It is a word that attempts to describe the multiplicity of ethnicities and experiences related to the international Indigenous, Black, Pan-African, Afro-descendent, Arab, Brown, Latinx, South American, and Asian communities.

Empowerment: The process of reclaiming control and power over your existence as a deeply rooted person.

Healing: A difficult and laborious yet necessary mental, physical, and spiritual process that we must undergo in order to achieve well-being, particularly after experiencing trauma. Healing can happen on both individual and collective levels.

Indigenous: See *deeply rooted*.

Intergenerational trauma: The transferring of unhealed trauma from one generation to the next.

Intervention: A rupture in the daily lives of people in the form of art that encourages critical thinking.

Liberation: True freedom of the mind, body, and spirit. Freedom that is not given but is struggled towards and taken.

Margins: The peripheries of the center, inhabited by people who are assumed to be powerless or secondary.

Marginalized people/communities: See *deeply rooted*.

New narratives: An approach to the practice of counternarratives that actively seeks to alleviate the burden of constant correction too often placed on the shoulders of deeply rooted artists.

People of color: See *deeply rooted*.

Safe space/Safer space: A space—that may be physical or not—where you feel protected from harmful and triggering experiences that impact your mental, physical, emotional, and spiritual well-being. A space free of the perpetuation of racist, sexist, patriarchal, homophobic, transphobic, classist, and imperialist thought and action.

Self-care: To actively work on the balance between mind, body, and spirit.

Self-determination: To intentionally and rightfully reclaim control from external sources of power in the process of striving towards liberation.

Struggle: A lived experience marked by an intimate understanding of efforts towards true liberation. The experience can be personal, political, and/or spiritual.

Systemic change: The urgent need for a complete and fundamental shift in the web of systems that uphold harmful values, such as colonialism.

Systemic racism: Embedded racism and discrimination permeating all levels of social, political, and economic policies and practices.

TCOYS: Abbreviation for "Take Care of Your Self."

Transformation: A phenomenon related to healing that leads to a powerful elevation of mental and spiritual consciousness.

Transnational solidarity: Mutual support and respect among deeply rooted people and communities involved in international struggles for liberation.

Well-being: A human right to wellness and care that we all deserve to experience.

INDEX

ABOUT THE ARTISTS

Leila Abdelrazaq is a Palestinian author and artist born in Chicago and currently living in Detroit. Her debut graphic novel, *Baddawi* (Just World Books, 2015) was shortlisted for the 2015 Palestine Book Awards and has been translated into three languages. Leila is cofounder of Maamoul Press, a multidisciplinary collective creating, curating, and disseminating works by marginalized creators at the intersections of comics, print making, and book arts.
lalaleila.com / @lalalaleilala

Allos Abis is a community organizer and youth arts educator.

Susu Attar is a multimedia artist born in Baghdad and raised in Los Angeles. Throughout the various manifestations of her work, Susu leads her audience on a search for moments of empathy and transformation. She is a member of SEPIA Collective, an artist-run organization whose work includes organizing the *ICONIC: Black Panther* exhibition.
susuattar.com / @susuhantusu

April Banks is an artist, traveler, and the producer of *Tea Afar*, a nomadic storytelling project. Her creative career spans art, design, and social practice. As a traveler and story maker, she explores the complicated privilege of a being a Black woman with an American passport. Her life goals involve squeezing bread and other people's babies.
aprilbanks.com / @teaafar

Monique Bedard (Aura) is a neurodiverse Onyota'a:ka/French-Canadian art maker who is currently based on Dish With One Spoon Territory, in Tkaronto. Aura is also a Diploma Toronto Art Therapy Institute Candidate working on an art as transformation/healing program called "Our Stories Our Truths" (OSOT) that is dedicated to creating a safe space for urban Indigenous youth to connect with and build meaningful relationships with mentors in the Indigenous community of Tkaronto.
moniqueaura.com / @monique.aura

Sadaf Rassoul Cameron is a first-generation Afghan-American artist who uses photography, words, and time travel to document and express a post-apocalyptic narrative. Sadaf has exhibited her work in various international venues. Sadaf's work is part of the permanent collection at Albuquerque Museum of Fine Art. Sadaf is currently the Director of Kindle Project.
sadafcameron.com / @sadafcamera

Joseph Cuillier is a multidisciplinary artist from New Orleans who explores abstraction as a technology, language in space, and the history of Black radical pedagogies through social practice, installation, textile art, and design. Cuillier's

installations use fashion and architecture to render bodies in space and bodies in action, attempting to bridge gaps between living and form. He is the founder and codirector of The Black School, an experimental radical Black art school, and the art and music festival Black Love Fest NYC.
josephcuillier.com / @josephcuillier

Dana El Masri is an Arab-Canadian perfumer and interdisciplinary artist. She is the owner and creator of Jazmin Saṛaï, a perfume brand exploring scent, sound, and culture. Her interdisciplinary work includes olfactory installations, most recently revolving around multisensory movement and synesthetic practice, such as in the piece Σmotion.
jazminsarai.com / @jsparfums

Jess Glavina is a second-generation Canadian settler writer, geographer, media- and performance-maker, and manual therapist. The theater piece *ACOUS!: A Chorus of Unidentified Singers* was supported by the Revolution They Wrote Short Works Feminist Theatre & Performance Festival in Tio'tia:ke (2016), with dramaturgy by Adjani Poirier and developed-in-process with Annick MF and Teeanna Munro. The second iteration was at the invitation of Shanna Strauss for the 2016 World Social Forum in Tio'tia:ke.

Narmeen Hashim is a mixed-media artist, urban researcher, and community arts educator based in Ojai, California. From large-scale aerosol art productions, to ink illustrations, to outdoor installation, Narmeen believes in the healing potential of art-making for the self, communities, and landscapes. Her work is largely influenced by her spiritual practice, Pakistani heritage, and fascination with human resilience.
narmeenhashim.com / @themeeningoflife

Samira Idroos is a multimedia artist and creative director based in Los Angeles. Her works combine existing prayer rugs with textiles and embroidery representative of the complexities in culture growing up as a Sri Lankan Muslim-American in Los Angeles. Samira has exhibited in Los Angeles, San Francisco, Berkeley, and Montreal.
samiraidroos.com / @sidroos

Tara Jaffar's work creatively explores themes of identity and belonging, particularly in relation to difference and diversity. This includes work with Middle Eastern diaspora such as *Stories My Mother Told Me* and *Chew & Glue*, as well as *IamResilience*, which involved facilitating creative-therapeutic groups for healing trauma inside a Syrian refugee camp in South Lebanon.
starakin.com

Julay aka **Sacred Spirit Ink** is a queer mama, handpoke ritualist, and *bruha* artist weaving our cosmic web through spirit ink, anting-anting, and visual art. A survivor of sexual abuse, they are committed to curating a safe space in their

ancestral healing work. Through *batok* [the traditional Filipino tattoo ceremony], the markings waiting beneath the skin surface, they help facilitate the release of grief, pain, and intergenerational trauma stored in our bodies.
@sacred.spirit.ink / sacred.spirit.ink@gmail.com

Suhad Khatib is a multimedia artist born in Oman, raised in Jordan, and currently residing in San Francisco. Suhad is a public speaker on the subjects of Palestine, theology, feminism, and community organizing. She is the designer behind prominent social justice campaigns that have shaped our understanding of recent history: #Ferguson2Palestine, #ISupportRasmea and #ShowMe15. She was one of the founders of the film industry in Jordan and has written and directed multiple short films.
suhadkhatib.com / @su.had

Jihan Kikhia's most cherished value is curiosity. She is committed to discovering how free expression can be a vehicle for empowerment and understanding. Jihan is currently directing and writing her first documentary film about the disappearance of her father, an opposition leader to Qaddafi's regime.
jihanart.com / mansurkikhia.org / @jihanlovesart

Annick MF is a mama, creative maker, community organizer, and wellness advocate based in Tio'tia:ke (Montreal), on traditional Kanien'kehá:ka territory. She is the founding coordinator of the Black Perspectives Initiative (BPI), a Black community hub within Concordia University for Black students, staff, and faculty across the spectrum of their needs, desires, perspectives, and initiatives. She also hosts a radio show on mental wellness and relationships called "It Could All Be So Simple" on CKUT radio.
annickmf.com / @itsannickmf

Niti Marcelle Mueth is a multidisciplinary visual artist. She uses illustration, animation, and serigraphy to reflect on the experiences of individuals from marginalized classes.
nitimueth.com / @nitimueth

Teeanna Munro is a spoken-word artist and writer whose work focuses on storytelling as identity, resistance, and celebration. Her work has been published in *The Great Black North: Contemporary African Canadian Poetry* and *Geist*. Her performances have been featured in The Congress of Black Writers and Artists, National Youth Arts Week, and others. Words that ignite her spirit are family, oral tradition, heritage, community, preservation, generations, and memory.

Ahmad Naser-Eldein is a photographer born in Jerusalem. His work explores the lines between documentary and imagination. His studio and home photography explores humans while celebrating their uniqueness and diversity. Ahmad regularly contributes to various print publications and has participated

in multiple solo exhibits and collaborations in Palestine and Canada as well as through online platforms. His research interests tackle representation of queer and political identities.

itsahmad.com / @ahmadnasereldein

Nora Patrich is an accomplished painter, muralist, print maker and sculptor. She creates beauty, records history, and, when necessary, denounces injustice. A feminist in essence, women are a principal and constant presence in her work. We see them through Patrich's eyes as the pillars of society in their many pivotal roles: as mothers, sisters, workers, friends, and lovers. She currently divides her time between her studios in Vancouver and Buenos Aires.

Jessica Powless is Wolf Clan from the Oneida Nation of Wisconsin. She works for the Oneida Language Department and is a language trainee, teacher, and digital artist. Writing and painting have been her loves since she was nine years old. Jessica grew up on the Oneida reservation and has traveled to numerous reservations across the United States and Canada for longhouse ceremonies and to hear the languages of her people. She traveled across the United States in 2011–2012 on the Walk for Human Rights, meeting other Indigenous people across Turtle Island, which inspired and pushed her into new ideas for her art.

@whensdayaddams

Roï Saade was born and raised in Lebanon, and is an independent visual designer working in both graphic design and photography. Roï uses photography as a tool to access unfamiliar places, challenging himself to connect with strangers while interchangeably observing life from a distance in its form and content.

roisaade.com / @roisaade

Soukayna (she/they) is a multidisciplinary artist, curator, and writer. Soukayna's work is largely motivated by the dichotomies of their identity as a queer Muslim Moroccan, and aims to center marginalized voices and erased histories in their writing and artistic practice. In 2018, Soukayna published *WORDS*, a book of poetry based on their personal experience with home, longing, abuse, mental health, and healing.

soukayna.net / @lucidcorpse

Shanna Strauss is a Tanzanian-American visual artist living and working between Tiohtià:ke/Mooniyaang (Montreal) and Ohlone Territory (Oakland, CA). She completed a BFA at the California College of Arts and has exhibited in solo and group shows in Tanzania, Canada, the US, and Senegal. Her work has been shown in *Emboldened, Embodied* at Thacher Gallery (University of San Francisco); *Women Pathmakers* at Euphrat Museum of Art, Cupertino; and *Here We Are Here: Black Canadian Contemporary Art*, Montreal Museum of Fine Arts.

shannastrauss.co / @shanna.strauss

ABOUT THE AUTHOR

Sundus Abdul Hadi is an artist and writer of Iraqi origin. She was raised and educated in Tiohtià:ke/Montréal, where she earned a BFA in Studio Arts and Art History and a MA in Media Studies. Articulated through her artistic practice, writing, and curation, Sundus' work is a sensitive reflection on trauma, struggle, and care. She is the author-illustrator of *Shams*, a children's book about trauma, transformation and healing. She is the cofounder of We Are The Medium, an artist collective and culture point.

Abdul Hadi's work has been exhibited in Palestine, Canada, United States, United Arab Emirates, France, United Kingdom, and New Zealand. She has given workshops in Australia and Iraq, and has been a speaker at Nuqat (Kuwait); the Nobel Peace Prize Forum; Telfair Museums in Savannah, Georgia; the Aga Khan Museum; and multiple universities in Canada and the US. Abdul Hadi is a two-time recipient of the Conseil des Arts et des Lettres du Quebec (CALQ) Vivacite grant and received the Makers Muse award from Kindle Project. Her work is part of the Barjeel Art Foundation collection.

sundusabdulhadi.com / @sundusabdulhadi

ABOUT WE ARE THE MEDIUM

We Are The Medium (WATM) is a culture point and production house for communication through video, music, print, and visual art. Consisting of family members, the tribal structure of WATM offers a countermodel to the art industry, because decentralizing business from the arts is what creates cultural currency. Our work is intentional, intuitive, and fiercely independent. Our ethos, "independent is the new major," permeates throughout all our works, presence, and internal dialogue. In a world on the cusp of change, being independent empowers our approach to cultural production, and is rooted in social justice. Representation, care, new narratives, and internationality are some of the common threads that link our projects, products, artwork, and curated events. We serve the community of the margins; deeply rooted, displaced, diasporic, undefinable. *Communication + Unity = Community.*

wearethemedium.com / @wearethemdm

ABOUT COMMON NOTIONS

Common Notions is a publishing house and programming platform that advances new formulations of liberation and living autonomy. Our books provide timely reflections, clear critiques, and inspiring strategies that amplify movements for social justice.

By any media necessary, we seek to nourish the imagination and generalize common notions about the creation of other worlds beyond state and capital. Our publications trace a constellation of critical and visionary meditations on the organization of freedom. Inspired by various traditions of autonomism and liberation—in the United States and internationally, historically and emerging from contemporary movements—our publications provide resources for a collective reading of struggles past, present, and to come.

Common Notions regularly collaborates with editorial houses, political collectives, militant authors, and visionary designers around the world. Our political and aesthetic interventions are dreamt and realized in collaboration with Antumbra Designs.

commonnotions.org / info@commonnotions.org

BECOME A SUSTAINER

These are decisive times, ripe with challenges and possibility, heartache and beautiful inspiration. More than ever, we are in need of timely reflections, clear critiques, and inspiring strategies that can help movements for social justice grow and transform society. Help us amplify those necessary words, deeds, and dreams that our liberation movements and our worlds so need.

Movements are sustained by people like you, whose fugitive words, deeds, and dreams bend against the world of domination and exploitation.

For collective imagination, dedicated practices of love and study, and organized acts of freedom.

By any media necessary.
With your love and support.

Monthly sustainers start at $10 and $25.

Join us at commonnotions.org/sustain.

Zapantera Negra:
An Artistic Encounter Between
Black Panthers and Zapatistas

Edited by Marc James Léger
and David Tomas (Editor)

978-1-942173-55-7
$22.00
272 pages

Grupo de Arte Callejero:
Thought, Practices, and Actions

Grupo de Arte Callejero,
translated by the Mareada
Rosa Translation Collective

978-1-942173-10-6
$22.00
352 pages